A WILD WEST HISTORY

of

FRONTIER
COLORADO

A WILD WEST HISTORY

of

FRONTIER

COLORADO

Pioneers, Gunslingers & Cattle Kings
on the Eastern Plains

JOLIE ANDERSON GALLAGHER

THE
History
PRESS

Published by The History Press
Charleston, SC 29403
www.historypress.net

Back cover top left image: *The Bucking Bronco* by Frederic Remington.
Courtesy of the Library of Congress.

First published 2011
Second printing 2012

Manufactured in the United States
ISBN 978.1.60949.195.6

Library of Congress Cataloging-in-Publication Data

Gallagher, Jolie.
A Wild West history of frontier Colorado : pioneers, gunslingers, and cattle kings on the
eastern plains / Jolie Gallagher
p. cm.
Includes bibliographical references.
ISBN 978-1-60949-195-6
1. Colorado--History--To 1876. 2. Frontier and pioneer life--Colorado. 3. Ranch life--
Colorado--History--19th century. 4. Plains--Colorado--History--19th century. 5. Colorado-
-History, Local. 6. Colorado--Social life and customs--19th century. 7. Pioneers--Colorado-
-Biography. 8. Outlaws--Colorado--Biography. 9. Ranchers--Colorado--Biography. 10.
Colorado--Biography. I. Title.
F780.G25 2011
978.8'01--dc23
2011037319

For Ed Anderson, who gave his little girl a pony.

Contents

Acknowledgments 9

1. The Argonauts **11**
The Claim Jumpers 13
Now My Wife Can be a Lady 18
The Smoky Hell Trail 22
Humbug or No Humbug 24

2. Politicians and Other Scoundrels **27**
The Code of Honor 29
The Gentleman Killer 33
Swift, Sure and Certain 35
Notorious Mountain Charley 39
Criterion for All Things Wicked 41
The Pistol-Packing Press 46
Picture of a Statesman 51

3. Rebels and Ruffians **54**
His Jury in Hell 56
The Devils from Pikes Peak 58
Dead Man's Canyon 62
The Raiders of South Park 67

CONTENTS

4. The People of the Plains **74**
The Panic 76
The Captives 79
The Massacre 85
The Siege 92

5. Vigilantes and Villains **97**
I'll Die Hard 99
Hell on Wheels 102
Scouts of the Prairie 105

6. Cowboys and Indians **110**
The Lone Range Rider 112
Wrong Turn Up a Cottonwood Limb 115
Texas Fever 117
The Last Dog Soldier 120
Trail's End 125

Epilogue 129
Notes 131
Bibliography 135
About the Author 143

Acknowledgments

In a time when the "tall tale" was the prominent form of entertainment, pioneers often stretched the truth in biographies, retelling their stories with a wink of an eye and a foggy memory. Newspapers were no more reliable; their editors occasionally printed satires, rumors or skewed facts. But through all the yarn spinning and sketchy reporting, the trailblazers presented an astounding history of Colorado's early days, where only the most rugged individual could survive hardships on the unsettled prairie. Drawing from their accounts, this book attempts to extract historical facts from the grand prevarications. It presents a true history of Colorado's eastern frontier—from the gold rush to the coming of the railroad—while also preserving an old yarn or two.

I want to thank all the dedicated curators, librarians and museum volunteers who assisted me with research, including Sarah Everhart at History Colorado, Coi Drummond-Gehrig and Bruce Hanson at the Western History Department of the Denver Public Library, Snow Staples at the Overland Trail Museum, Mary McKinstry at the Fort Sedgwick Historical Society, Mary-Jo Miller at the Nebraska State Historical Society, Mary Wallace at the Pueblo County Historical Society, and Barbara Barbaro and Don Kallaus at the Old Colorado City Historical Society. I especially want to thank Carol Turner for reading my draft and offering her encouragement, Jeff Broome for answering my emails and Byron Hardwick for providing his expertise in antique firearms. And finally I must acknowledge my marvelously supportive husband, Sean Gallagher. He read my drafts, created maps, took photos and generally held down the fort while I wrote. Without him, this book would not have been possible.

Chapter 1

The Argonauts

Not every man stands over his own grave. But in 1859, Daniel Chessman Oakes pondered a rubbish-filled hole and mock headstone that bore his name: "Here lie the remains of D.C. Oakes, Who was the starter of this damned hoax!"[1]

Scrawled on buffalo bones in mixtures of charcoal and axle grease, the chilling epitaph greeted Oakes and his business partners along a lonely stretch of trail. The sight not only alarmed Oakes, it also confused him. An experienced prospector at age thirty-four, he had spent the previous summer scouring the South Platte River and the surrounding tributaries near present-day Denver. While at the base of the mountains, Oakes met with early prospectors in the area, men like William "Green" Russell and his party from the mines of Georgia. Russell had discovered small quantities of placer gold on Little Dry Creek in 1858. It wasn't much, but it was no hoax either.

One member of the Russell party, Luke Tierney, had documented the finds in his personal journal and showed his notes to Oakes. Impressed with Tierney's account, Oakes persuaded the Georgia miner to let him use the notes as the basis for a gold-seekers guide. Oakes appended his own travel advice, returned to Iowa and secured businessman Stephen Smith as a publishing partner. Smith printed *History of the Gold Discoveries on the South Platte River* in the winter of 1858–1859 and distributed copies to outfitting stations in Missouri River towns.

Within weeks of its publication, the Smith & Oakes guide and others like it spawned the hopes of eighty thousand people, launching one of the greatest

migrations in American history. To his credit, Oakes accurately described the barren landscape and adverse conditions, but that didn't stop would-be prospectors from embarking on a six-hundred-mile journey across dry and dangerous territory. Like the mythical Greek Argonauts seeking the Golden Fleece, desperate men crossed the plains through unknown perils, with no railroads, no stage coaches and poorly marked trails to guide them. Some rode comfortably in ox-drawn wagons, bearing optimistic slogans such as "Pikes Peak or Bust," while others pulled handcarts or walked with packs over the bleak wilderness. All believed the journey would amply reward their efforts. They imagined riverbeds of riches waiting for them, some so hopeful that they brought empty flour sacks in anticipation of filling each one with gold. Yet when the exhausted pilgrims finally arrived at the confluence of the South Platte River and Cherry Creek, the novice gold seekers dug up nothing but rocks and sand. The furious masses turned back for home and, along the way, left effigies and graffiti to express their disgust at the gold promoters.

Below present-day Julesburg, Oakes stood over the mound the go-backers had left behind. His partners were as solemn as if they attended a real funeral. They told him, "Oakes, that crowd has buried you here. That means murder if they ever meet up with you."[2]

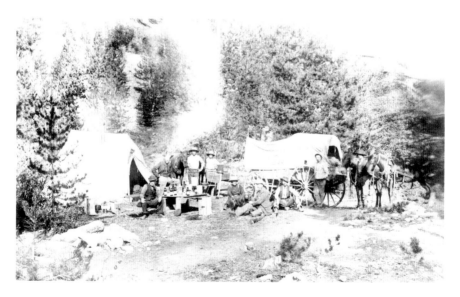

Pikes Peakers camping in the mountains. *Courtesy Denver Public Library Western History Collection, X-21803.*

In an unsettled, lawless territory, Oakes found himself on a collision course with thousands of prospectors, opportunists, gamblers and outlaws. And hoax or not, Colorado's Wild West was born.

THE CLAIM JUMPERS

In the 1850s, Americans knew little about the far reaches of the plains. Maps of that decade referred to the terrain between the Missouri River and the Rocky Mountains as the "Great American Desert" or the "Pikes Peak region." To city dwellers of the East, the western territories were vast and unexplored—as alien as the moon. But to some adventurous spirits, the uncharted country presented an opportunity to seek their fortune.

In September 1858, several groups of Kansas businessmen packed for their first trip west. The businessmen heard rumors that the Russell party found gold in the Pikes Peak region (then part of Nebraska, Utah, New Mexico and Kansas territories). But they didn't intend to pan for gold themselves. Instead, they hoped to establish a town charter and sell tracts of land in the newly formed Arapahoe County, Kansas Territory, where Russell was prospecting. Before leaving, they met with the governor of the territory, James Denver. The governor selected county officers among the businessmen, giving them appointments such as commissioner, judge and sheriff, although the titles were meaningless. The land was established Indian territory where few white people had ventured.

The first group outfitted from Lecompton, the territorial capital. With this group of seventeen men was Edward "Ned" Wynkoop, the youngest son of a prominent Pennsylvania family. At twenty-two, Wynkoop was still an impetuous youth but also politically savvy. After befriending Governor Denver, Wynkoop received an appointment as sheriff of Arapahoe County. He later joked in his autobiography about the weightless title, writing how his duties would include keeping the buffalos and Indians in order—"a nice crowd to summon a jury from."[3]

Wynkoop should not have joked about the Indians. Not long into their journey, a band of Kiowa approached his group on the Santa Fe Trail. The warriors saw that Wynkoop rode a fine horse and challenged him to a race against their best rider. Impetuously, Wynkoop accepted. On the signal, they

laid into their horses for all they were worth, racing neck and neck across the prairie with Wynkoop edging just inches ahead. In the midst of the excitement, Wynkoop heard the startling crack of a gunshot and reined in his horse. He checked his rifle lying sideways in front of him on the saddle. It still smoked from the apparent contact with the pommel. With a sinking feeling, he realized his firearm had accidentally discharged during the race, its lead ball passing narrowly in front of his challenger. From behind, Wynkoop heard angry shouts and turned to see all the warriors riding hellbent in his direction. With frantic hand gestures, he tried to explain that the shot was an accident. He never touched the rifle; he never meant to harm anyone. As the warriors advanced on him, Wynkoop's friends took up arms and prepared for a fight. He turned to his challenger and tried to explain the mishap. Fortunately, the Kiowa understood and stepped up in his defense, thus averting bloodshed.

Wynkoop later speculated on how they avoided a fight with the Plains Indians: "I know for a fact that they are not the first to precipitate a war, and whenever Indian hostilities have taken place war has been forced upon them by action of the whites."[4]

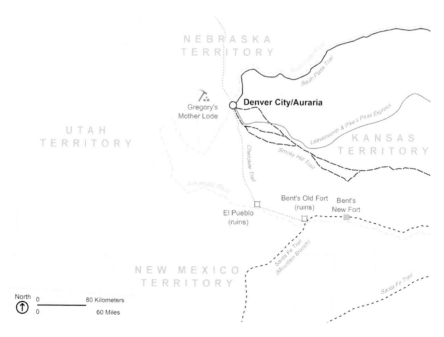

Pikes Peak region in 1858–1859, showing the main trails into the territories. *Map by Sean Gallagher.*

Days after the Wynkoop party departed, a second group of officials outfitted from Leavenworth. Leading this party was General William Larimer. As the eldest member at age forty-nine, Larimer felt confident that his business acumen would pay off in the Pikes Peak region. With his group was his seventeen-year-old son, William H.H. Larimer. Writing about their experiences in later years, William said that as news of gold strikes spread through Leavenworth, hundreds of eager citizens from bankers to loafers held meetings on street corners. So many planned to go west that he imagined half the population would drain away. At first, nearly eighty men asked to join their group. But as the day neared for departure, the old frontiersmen discouraged them with tales of hostile Indians, snowstorms and every imaginable danger. Of the original volunteers, only six enlisted for the journey.

One of the doubters approached the teenage Larimer as he loaded the wagons. William wrote,

> *The first thing we put into the bottom of our wagon was six light pine boards. We did not know just what we might want to use them for, but a fellow who was standing close by when we were loading them on the wagon remarked that they would be used for coffins... While I pretended to take no notice of his remark, I felt as if there might be some truth in it, and there was many a time afterwards when I recalled to mind his jest, and wondered if it was about to prove true.*[5]

Ignoring the taunts and also the pleas from his mother to reconsider, the determined youth set off with his father in a group that included Charles Lawrence, Richard Whitsitt and several others. On the Santa Fe Trail, the men traveled blindly without any knowledge of the country and without meeting a single white person in either direction. As they neared Bent's New Fort, which was the only outpost of civilization for hundreds of miles, they saw three riders coming from the west. One was Green Russell, a sorry sight after months of prospecting. His clothes were tattered and dirty, and his beard plaited into two long braids. Yet William described him as "the inspirer of all our hopes."[6] As they talked, Russell encouraged the Kansas men to push on toward Pikes Peak. Gold could be found, he assured them, and they planned to return with better equipment for extracting it.

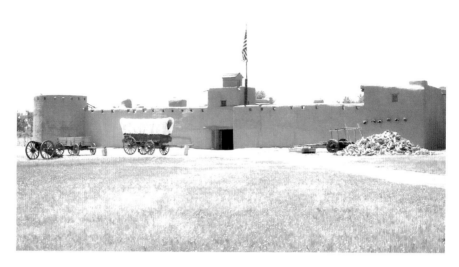

Bent's Old Fort National Historic Site. *Photo by Sean Gallagher.*

General Larimer caught up with Wynkoop's men at the abandoned ruins of the old trading post, El Pueblo (present-day Pueblo). The combined group then pushed one hundred miles north until they ascended a hill and spied a bustling settlement along the banks of Cherry Creek. As they drove their wagons around the tents, teepees and rough log shacks, they felt their business aspirations shrivel and die. Almost three hundred people had beat them to the region. Early prospectors from the Russell party had laid claim to a town site on the west bank, calling it Auraria for their hometown in Georgia. Other gold seekers had just arrived via the northern route along the South Platte River, some setting up tents and selling goods. Trappers had also settled in for the winter with their Arapaho wives and relatives.

Although late to the region, General Larimer didn't abandon their plans for a town company. As the Kansas men unpacked their wagons and divided up the supplies, the general scrutinized the Auraria landscape. He wasn't satisfied with its low bank along the creek, which would be prone to flooding. Abruptly, the general grabbed some provisions and told his son to yoke up the oxen and follow him to the higher, eastern bank. With a heavy sigh, the teenager repacked the wagon and drove it through the sandy creek and up

the steep bank. General Larimer waited for him on the other side with a campfire blazing and four cottonwood poles crossed together, creating the first "Larimer Square."

Even with the construction underway, General Larimer had a slight problem. Near his camp, another cabin sat on the east bank, looking abandoned in its half-finished state. Before Larimer arrived, several businessmen had already marked off 640 acres for a town they wanted to call St. Charles. The St. Charles men had asked two mountain men named William McGaa and John Smith to guard the site, while the rest traveled to Lecompton to secure a charter. But they should never have trusted McGaa and Smith. The two frontiersmen already owned shares on the Auraria side and had little interest in St. Charles. When Larimer began building his cabin, they took no notice.

Meanwhile, the St. Charles men traveled down the South Platte River and met several groups of gold seekers headed to the mountains. They worried that more people would follow. One of their leaders, Charles Nichols, decided to turn around and guard the claim himself, not realizing that he was already too late. When he arrived back at Cherry Creek, Larimer and

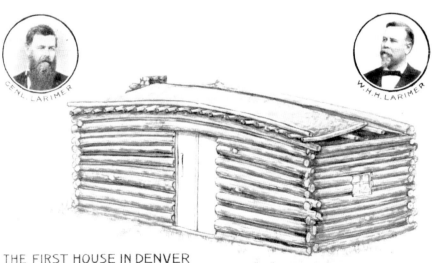

THE FIRST HOUSE IN DENVER
RESIDENCE OF GENL. LARIMER-BUILT IN 1858 AT 15TH & LARIMER STS.

Cabin built by General William Larimer and his son, William H.H. Larimer, in 1858. *Illustration from* Reminiscences of General William Larimer and of His Son William H.H. Larimer.

17

his party had jumped the site and temporarily moved into his half-finished cabin. Nichols confronted them, arguing that the land was platted for the town of St. Charles. He stood his ground boldly but futilely until the Kansas businessmen dangled a noose in his face. Defeated, Nichols agreed to negotiate.

As for McGaa and Smith, they willingly sided with the claim jumpers. McGaa even offered his Auraria cabin for their first meeting, where they settled the details "under the relaxing influence of a pot of hot and powerful frontier whiskey punch provided by the host."[7] With no more talk of lynching or claim jumping, their final task was to agree on a name for the east-bank town. The Kansas men finally won the argument for "Denver City," in honor of the territorial governor James Denver. Unknown to them, Governor Denver had resigned several weeks before.

NOW MY WIFE CAN BE A LADY

Newspapers from Boston to St. Louis readily published anything they could about gold strikes in the Rocky Mountains, whether fact or fiction. William Larimer wrote, "Almost invariably the papers would add another zero to the row of digits sent by the correspondent: thus '$2.50 per day' with a rocker would become '$25.00 per day' when inserted in the newspaper."[8] The *New York Times* even heralded the Pikes Peak region as "the New California."[9] With all the exaggerated tales of riches to be found, the rush would soon become a stampede.

In Omaha, a shrewd businessman watched as waves of gold seekers rippled west. At twenty-eight, William Byers had already established himself as a successful engineer and government surveyor, but the mass migration gave him an idea for a new enterprise. Knowing that the exploding population would want a local newspaper, Byers and several partners purchased a second-hand printing press and decided to join the tide. That spring of 1859 was wet and cold, making for a miserable trip. Delayed everywhere by high water, snow and soft ground, Byers said it was discouraging to work all day at making progress with their heavy wagons, only to stop within sight of the previous night's camp.[10] Further hindering their journey, the Indians had burned off the native grasses, leaving no food for the horses and oxen.

The Indians were the least of their worries, though. Mixed in with the hoards of immigrants were thieves and gamblers—about the roughest lot of men they ever encountered. One of his partners said, "The Byers party preferred to take chances against redskin raids rather than camp with some of the white travelers they met. Some of the pioneers were of the hardboiled variety…and suspected of being not above a bit of brigandage to fatten their lean pocketbooks."[11]

After weeks of rough and unnerving travel, Byers reached the base of the mountains and met the Russell party, who were gold panning with small success. Encouraged, Byers rode on to the Cherry Creek settlements where he beheld a sorry sight of ragged tents, broken-down wagons and gaunt animals scattered throughout the spindly cottonwoods. He also discovered he had competition. Just four days before, an immigrant named John Merrick had arrived with a printing press for his *Cherry Creek Pioneer*. Fortunately for Byers, Merrick had done little to begin setting type.

Refusing to be beat, Byers rented space in the first business building in Auraria, a two-story clapboard structure owned by a frontiersman from

Uncle Dick Wootton's Western Saloon, with the *Rocky Mountain News* office in the attic, 1859. *Drawing by Richard Turner.*

Kentucky, Richens "Uncle Dick" Wootton. The first floor served as a trading post and saloon, while the sloped attic provided just enough room for the printing press. The Byers team promptly set up their equipment under a flimsy roof that dribbled water and dirt on them like a sieve.

When Merrick learned about Byers, the race was on. Merrick hired employees and established his operation on the Denver side of the creek. For several days, town citizens scurried back and forth between the news offices, checking progress at one printing press and then splashing over the creek to check the other. The gamblers among them exchanged bets as to which man would be the first to print a newspaper. Merrick had arrived there first, but Byers had an edge. Before packing their wagons in Omaha, associate John Dailey had already set type for one page of their two-page publication.

At 10:00 p.m. on April 22, 1859, Byers and Dailey emerged from Wootton's attic, waving the first edition of the *Rocky Mountain News*. Across the creek, Merrick rolled the *Cherry Creek Pioneer* off the press just twenty minutes later. Merrick lost the contest. The next morning, Merrick traded his equipment for twenty-five dollars' worth of flour and bacon and headed for the mountains, deciding he would rather seek his fortune in gold.

Over the next six months, Byers continued to use the Wootton attic under impossible conditions. From above, the roof continued to leak, forcing them to set type under a tarp. From below, Wootton's saloon did a booming business in rot-gut whiskey, attracting rowdy customers who were reckless with their firearms. On lively evenings, as the drunken customers whooped and discharged their pistols, the printers upstairs dodged the lead balls zinging through the floor boards. Fed up, they finally laid down extra planks and straw mattresses to deflect the projectiles.

Byers may have won the competition for the first newspaper, but he still worried about his business. If a mother lode wasn't discovered soon, the Cherry Creek settlements would fade into ghost towns. Only traces of placer gold had been washed from the streams, not enough to keep the twin cities of Auraria and Denver thriving. Yet thousands of immigrants and desperate characters continued trailing into the territory, creating an unstable and dangerous environment. Along a creek, the first murder occurred when a prospector shot his brother-in-law for a bag of gold dust. In a saloon, a gambler gouged out his rival's eye with a bowie knife; in turn, the man knifed the gambler in the gut and spilled out his entrails. In a lonely tent,

a despondent and starving immigrant inserted the muzzle of a rifle in his mouth and pulled the trigger with his toe.

With all the tales of horror, the go-backers returned home like a routed army. Disgruntled, they declared the gold rush as "the great Pikes Peak hoax" and repeated nasty rumors to the eastern papers: the town founders were lynched, the towns were burned and the wagon trains were robbed. Those same papers that had printed promising stories of riches quickly changed their tune and claimed it was all humbug. To prove them wrong, Byers rode to the mining camps and interviewed experienced prospectors. With accurate detail, he reported all the small finds in the *Rocky Mountain News*. But eastern papers assumed Byers was only trying to save his business. Cynically, they labeled his newspaper the *Rocky Mountain Liar*.

Just as folks began to lose hope in May 1859, a scraggly prospector smiled and muttered to himself as he prepared for a return trip up Clear Creek. John Gregory, whom Byers described as "white trash," had already explored the mountains and staked a claim near present-day Black Hawk. No one suspected that the eccentric miner was keeping a huge secret. After restocking his supplies, Gregory tramped back up Clear Creek and found the same spot he had located in the winter, a place where he had washed a significant amount of gold. With pan and sluice, he washed $4 in gold flakes, then $40 days later. By the end of the week, he had gathered over $900, worth $25,000 in today's dollars. Supposedly, Gregory announced to everyone around him, "By God, now my wife can be a lady" and "My children will be schooled!"[12]

Word of the discovery spread like grass fire. When Gregory began picking at the creek bed, only seventeen other prospectors worked nearby. Weeks later, a reported thirty thousand men swarmed the same area. On one of his news-gathering expeditions, Byers found Gregory squatting along the creek. When the editor asked Gregory for an interview about his finds, Gregory casually leaned back and lifted a frying pan at his feet. Underneath lay three hunks of gold, worth $400 each. Elated, Byers reported the significant find. No longer did prospectors gather flakes and dust, they extracted hunks of gold in paying quantities.

As the eastern press picked up his reports, a few eastern journalists wanted to see the gold for themselves. Among them was the influential *New York Tribune* editor, Horace Greeley.

THE SMOKY HELL TRAIL

The journalist Albert Richardson enjoyed the journey west. After boarding one of the first Concord stage coaches bound for Denver, the *Boston Journal* correspondent reported on the quaint scenes along the trail: the prairie dogs, the buffalo, the friendly Indians and numerous travelers. Farther out, Richardson's journey grew much less pleasant. Over the newly blazed route of the Leavenworth & Pike's Peak Express, he jostled violently in the coach, its wheels hitting dry creeks and gullies with perpendicular banks. When Richardson thought he could no longer tolerate the molar-rattling ride, the conditions only worsened for him and his travel companion. As the coach ascended a steep slope, the driver raced the mules blindly over a ridge and plowed into three mounted warriors.

Richardson wrote:

> *Our mules, terrified by meeting three savages, broke a line, ran down a precipitous bank, upsetting the coach which was hurled upon the ground with a tremendous crash, and galloped away with the fore-wheels. I sprang out in time to escape being overturned. From a mass of cushions, carpet-sacks and blankets soon emerged my companion, his head rising above the side of the vehicle…Blood was flowing profusely from cuts in his cheek, arm and leg.*[13]

Arapaho Chief Little Raven visits journalist Albert Richardson in his Denver cabin. *Illustration from* Beyond the Mississippi.

His companion was Horace Greeley, the famous editor and politician credited with the slogan, "Go west, young man!"[14] After his ride across the central plains, Greeley may have uttered more choice phrases.

In 1859, several trails brought immigrants into the region: the northern route that followed the South Platte River (later called the Overland Trail), the southern route that followed the Arkansas River and then skirted the Front Range (the Santa Fe Trail and Cherokee Trail) and central routes that tracked the Republican and Smoky Hill Rivers through Kansas (the L&PP Express route and the Smoky Hill Trail). Of these, the Smoky Hill was by far the most dangerous. Once the trail reached eastern Colorado, it stretched over 150 miles of dry plains with no trees, no game and little water for days on end. The hazardous conditions didn't stop civic boosters in eastern Kansas from promoting it to gold seekers. Anxious to lure traffic to their towns, they advertised the shortest, most direct route to Denver as the Smoky Hill Trail. But after crossing it, travelers would soon dub it the "Smoky Hell Trail."

According to George Bent, the son of Bent's Fort proprietor William Bent and a Cheyenne woman, the Plains Indians were stunned when they saw thousands of people traversing the central trails:

> *Even the Smoky Hill and Republican routes were used by parties which attempted to cross the sandy waste east of Sand Creek, and here, old Cheyenne men have told me, the Indians found many a white man wandering about, temporarily insane from hunger and thirst. The Indians took them to their camps and fed them. They did not understand this rush of white men and thought the whites were crazy.*[15]

In May 1859, a stage coach brought a mere shell of a man into Denver after he was discovered lying on the prairie, emaciated and delirious. A passenger described him as a skeleton, "with cheeks sunken and his eyes protruded from their sockets."[16] Near dead, the man could barely walk and lost much of his eyesight. While recuperating in Denver, he revealed the entirety of his grisly tale to the L&PP Express company.

The man said his name was Daniel Blue, and he had started on the Smoky Hill with his two brothers and a single horse. When the horse went missing one morning, they decided to continue on foot. For several

weeks, they trudged over the prairie without incident until a spring blizzard overtook them. Having consumed the last of their food, the brothers became hopelessly lost in a five-day storm with no landmarks to guide them and gray clouds blotting out the sun. They walked in circles, confused and frozen, one hundred miles from Denver. When the storm cleared, they found their bearings and began walking again. They subsisted on dug-up roots and prickly pears, but it wasn't enough. The eldest brother collapsed. As he lay dying, he told his siblings to use his body so they may live. Daniel Blue later wrote, "After he had been dead two days, the uncontrollable and maddening cravings of hunger impelled Charles and I to devour a part of our own brother's corpse! It was a terrible thing to do, but we were not in a condition of mind or heart to do as we or other men would have done amid ordinary circumstances."[17]

Feeling stronger, they packed the remainder of their brother's flesh and resumed their journey. Locating a creek, they stopped to rest, but the youngest brother collapsed and died. Daniel Blue remained on that spot, lying by the creek and living off the flesh of his younger brother until an Arapaho Indian found him and carried him to a stage coach. The next day, the Arapaho man led the superintendent of the stage line to the spot where he found Blue. By the creek lay the remains of the brother. The superintendent reported that the corpse had "all the flesh gnawed from the bones, and the skull split open and the brains taken out."[18]

After only a few weeks, the L&PP Express company abandoned the central stage route in favor of the South Platte River trail. The gruesome reports of dead bodies and cannibalism along the road weren't particularly good for business.

HUMBUG OR NO HUMBUG

On his second trip to the region, Oakes and his party rode with the tide of immigrants in 1859. He cheerfully spoke with travelers and offered them advice on how and where to search for gold. Enjoying his popularity, Oakes said that everyone along the trail treated him with admiration as a person of authority. But halfway into the journey, he began to meet the go-backers. Of the twenty thousand immigrants on the South Platte trail that spring,

he said only four thousand got through to the gold fields, and it was those sixteen thousand, more or less, that he had the misfortune to encounter. Once someone exposed him as the man who wrote the guidebook, he wrote in his diary that "every man among them broke forth immediately into a string of frightful oaths, emphasized by gestures of so menacing a character that we hastily bade them farewell and speedily took our departure."[19]

Despite the threats, he continued on to the mountains, occasionally taking cover behind hills as hostile go-backers passed. Near present-day Julesburg, one of his partners found the grave where he was buried in effigy. At the sight, Oakes said he became "considerably alarmed at this evidence of my sudden loss of popularity and at the serious turn affairs had taken, which clearly boded nothing short of sudden death for me."[20] Even so, the grave wasn't enough to discourage him from reaching their destination. He was determined to prove that gold was no myth.

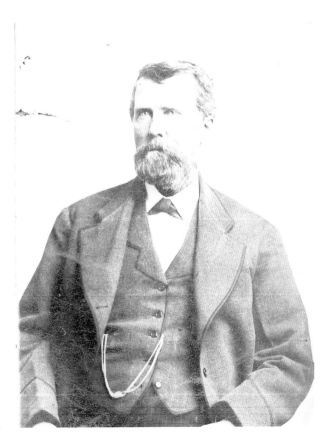

Portrait of Daniel Chessman "D.C." Oakes. *Courtesy Denver Public Library Western History Collection, Z-4894.*

As he continued up the trail, Oakes and a partner broke off and rode ahead of the wagons, no longer bothering to hide in the bluffs when confronted with men thirsting for vengeance. He eventually arrived at the mountains with his life intact, staked a claim above Boulder for his sawmill and set off again to locate his partners with the wagons. Oakes rode all day and night to regroup with his men, arriving only to find the camp abandoned and a note nailed to a tree. In the note, his partner wrote that he was discouraged and went home. Furious, Oakes pursued his business associates. They had become traitorous go-backers, and he wouldn't stand for it. Upon finding them at daybreak, he wrote that "in a few well-chosen words (which had best remain unprinted), I pointed out their error...and ordered them to yoke up the oxen and turn about." [21]

When the Oakes party reached his claim, he said that the immigrants' harsh feelings toward him had died down. The news of Gregory's discovery had already filtered through the region. Journalists Greeley, Richardson and Henry Villard interviewed prospectors and collaborated on an official report to the waiting world. They sent it by dispatch to Byers and Dailey for printing in a special edition of the *Rocky Mountain News*. (Unfortunately, Byers had no paper and frantically searched for any parchment he could find around Wootton's saloon. As a result, their special edition, announcing the discovery of the historic mother lode, was printed on brown wrapping paper.)

While Oakes felt vindicated after the gold strike, his wife back in Iowa worried for his safety. Wild rumors circulated that the gold promoters had been lynched, causing much anxiety to their families back home. Olive Oakes was desperate not only to receive news from her husband but to also send crucial news to him. In the four months of his journey, Olive had written letters that their daughter was ill, but none reached his hands until August when it was too late. In his absence, their little daughter had died.

Upon receiving the devastating news, Oakes wrote home to express his grief. He also poured out the emotional toll the journey had taken on him. He wrote how he was branded a villain as a promoter of the humbug, how even his friends pointed out his mad folly and how he slept but little, not for fear of death but rather for fear of what would be heaped upon him if the expedition proved a failure. He wrote to his wife, "Come through I would and come through I did...Humbug or no Humbug." [22]

Chapter 2

Politicians and
Other Scoundrels

When journalists Richardson and Greeley stepped off the Denver stage coach in May 1859, the state of the Cherry Creek towns surprised them. Greeley later described the visit, saying, "I apprehend that there have been, during my two weeks sojourn, more brawls, more fights, more pistol-shots with criminal intent in this log city of one hundred and fifty dwellings, not three-fourths completed nor two-thirds inhabited, nor one-third fit to be, than in any community of no greater numbers on earth."[23]

Richardson agreed with his assessment, adding that the inhabitants looked no better than the structures. Folks were grimy, hairy and tattered, with skin tanned and worn like shoe leather. As for ladies, the appearance of a bonnet on the street was cause for each man to stop and turn his head, just to catch a glimpse of that feminine curiosity. On the whole, the Pikes Peakers were a strange medley:

> There were Americans from every quarter of the Union, Mexicans, Indians, half-breeds, trappers, speculators, gamblers, desperadoes, broken-down politicians and honest men. Almost every day was enlivened by its little shooting match. While the great gaming saloon was crowded with people, drunken ruffians sometimes fired five or six shots from their revolvers, frightening everybody pell-mell out of the room, but seldom wounding any one.[24]

With an estimated four thousand people in Denver and thirty-five thousand in the entire gold region, the settlers wanted a more localized government.

New towns sprouted rapidly along the prairie and up the mountain valleys: Golden City at the entrance to Gregory Gulch, Boulder City and Laporte in Nebraska Territory, Colorado City at the foot of Pikes Peak and the twin villages of Fountain City and Pueblo down toward New Mexico Territory. Up in the mountains and all along the Front Range, anyone who could drive a stake in the ground claimed to have founded a new city, even though a lone prospector and his dog might be the only residents.

To make a case for a new territory with Pikes Peak at its center, frontier citizens sent a delegate to Washington, D.C., in the winter of 1858–1859. But the United States Congress had more serious matters to consider, especially with the escalating tensions between the northern and southern

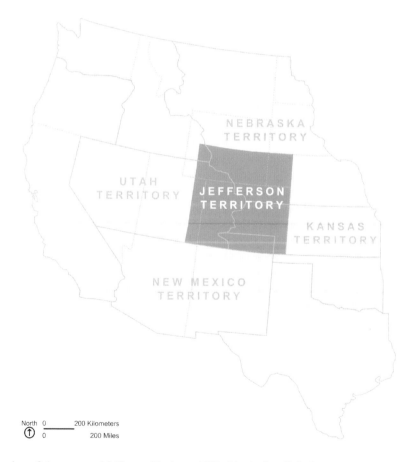

Borders of the proposed Jefferson Territory, 1859. *Map by Sean Gallagher.*

states. Indignant that Congress ignored them, the Pikes Peakers decided to form their own territory and named it "Jefferson." The promoters drew broad-reaching boundaries and elected their own officials while fully aware that their actions were illegal in the eyes of Congress. The gold region was officially part of Nebraska and Kansas Territories, causing some animosity among citizens still loyal to those governments. Even worse, the eastern plains were promised to the Indians under the Treaty of Fort Laramie, specifying that whites could not claim the land.

For all their diligent work, they mired themselves in a political mess. As William Byers editorialized, the region had a triple-headed government where one man claimed that he was part of the Jefferson domain, another that he was under Kansas or Nebraska law, while still another that he was on Indian land where no law could reach.[25] Under this tangled, lawless government, the Pikes Peakers were left to settle matters for themselves— usually with pistols.

The Code of Honor

In the waning light of an autumn afternoon, hundreds of spectators gathered along the banks of Cherry Creek to watch the impending bloodshed. At a deadly range of only ten paces apart, the two rivals took their positions, staring each other down in vain attempts to intimidate the other. Two respected leaders of the community, Richard Whitsitt and William Park McClure, intended to settle their disagreement with Colt Navy revolvers. Whitsitt was a soft-spoken Free-Soiler from the Kansas Larimer party, while his opponent, McClure, was a temperamental proslaver from Missouri. Apparently the two businessmen had squabbled over the establishment of the Colorado City town company in the summer of 1859. When their heated disagreement boiled over, McClure challenged Whitsitt to a duel. McClure was handy with a gun, but Whitsitt was shy with firearms and never carried one. The odds were in favor of McClure gunning him down.

Both men were friends of Ned Wynkoop, who still acted as the sheriff of Arapahoe County, although he was not yet paid to enforce any laws, even if laws existed. As Whitsitt and McClure readied their pistols, Wynkoop rode his horse through the bystanders and asked for their assistance in persuading

the men to stop. No one stepped up. When the citizens ignored his pleas, a dejected Wynkoop dismounted and folded back into the crowd. He watched as Charles Lawrence, Whitsitt's second, gave the ready signal and yelled, "Fire!" Whitsitt and McClure squeezed the triggers, their pistols discharging simultaneously. For an anxious moment, as the shots rang through Cherry Creek and the smoke cleared, both men held steady on their feet. Wynkoop looked to Whitsitt, unscathed and uninjured. Then he turned to his Southern friend. McClure grasped his groin and swayed backward. He told his doctor, simply, "I am hit."[26] His friends carried away the irascible McClure, who was seriously wounded but not fatally.

Only months later, Wynkoop found himself entangled in yet another duel. This time the disagreement arose between two Jefferson Territory officials:

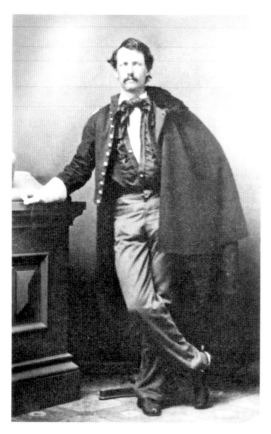

Portrait of Edward "Ned" Wynkoop, Denver, 1861. *Courtesy Denver Public Library Western History Collection, X-22195.*

the acting governor Lucian Bliss and a legislative member, Dr. James Stone. Although the men were colleagues, they stood on opposite sides of a political divide. Bliss was an ardent abolitionist, while Dixie-born Stone was a staunch proslaver. Their conflicts peaked at a dinner party of Jefferson officials at the Broadwell House in Denver. As the wine and whiskey rounded the table, the good-natured discussions devolved into gossip about the Southern sympathizer, Dr. Stone. Not only did they disagree with Stone's political leanings, they accused him of turning a blind eye to a lynching that occurred in the mountains. The heinous deed was under

his jurisdiction as the judge of a miner's court. Before Stone caught wind of the gossip, acting governor Bliss stood and offered up a toast to the twelve men at the table. In his speech, Bliss somehow managed to slip petty gossip into his remarks and insulted Stone. Incensed, Stone rose from his chair to confront Bliss for the slurs on his character. An argument ensued between the half-drunk men, concluding only when Bliss splashed a glass of wine in Stone's face. That ended the dinner party. Stone marched out of the dining hall, immediately locating friends to draft a formal challenge. Bliss did the same, turning to his friend, Sheriff Wynkoop, to act as his second.

Among gentlemen, dueling was a formal affair. It required written terms and agreements, much like any legal document today. All matters were arranged through the seconds, typically friends of the duelists. When Wynkoop received Stone's challenge to Bliss, he drafted the terms: shotguns loaded with one ball at thirty paces. Stone promptly accepted. The next afternoon, the two Jefferson officials arrived at the appointed hour, Bliss swaggering confidently with his gun slung over his shoulder, Stone looking pale and nervous as he arrived by carriage. As a crowd of eight hundred people gathered along the South Platte River, a citizen read the lengthy Articles of Agreement. The ten terms described the weapons, the distance, what they could wear and what would be said as the signal to fire. After Wynkoop helped pace off the grounds, the rivals took their positions and faced each other with readied shotguns. Stone's second made the final count and yelled the signal, "Fire-one-halt!"[27] The nervous Stone fired first, hastily, without raising the gun to his shoulder and without hitting his opponent. The lead ball plowed harmlessly into the dirt. A split second later, Bliss fired low and hit Stone in the leg, an injury that crumbled him to the ground. Bliss only intended to graze Dr. Stone, but the ball deflected off his thigh bone, tore into his bladder and passed through his back. The wound was fatal. For the next six months, Stone lingered and suffered, dying by inches.

When Dr. Stone finally succumbed to death, Byers denounced the code of honor in his paper: "Duelling [sic] is but a relic of an age of barbarism, and its code should pass unknown and unrecognized among those who claim to live and act in the middle of the nineteenth century."[28]

The pleas from Byers didn't stop the practice. Months later, Park McClure recovered from his dueling injury to cause more trouble. Although known about town as a bully that earned him the nickname "Little Thunderer,"

McClure managed to secure himself an appointment as Denver postmaster. One December day, when Wynkoop entered the post office to retrieve his mail and greet his postmaster friend, McClure assaulted him with a barrage of verbal abuse. He yelled at Wynkoop for not paying his postal fees and refused to hand over his mail. Wynkoop stubbornly refused to settle his bill, prompting the incensed McClure to write a formal challenge. Wynkoop coolly accepted, confident in his abilities. Since his days back in "Bleeding Kansas," where guerilla warfare had erupted between Free-Soilers and proslavers, Wynkoop had spent many hours practicing on the firing range in preparation for attacks from Missouri bushwhackers. He also worked as a barkeep at the Criterion, a saloon infested with scoundrels and slackers, none of whom could intimidate the six-foot, three-inch sheriff. Lanky and imposing, Wynkoop wouldn't hesitate to draw pistols on unruly customers or jump over the bar to break up knife fights.

In response to McClure's challenge, Wynkoop grabbed a pen and wrote out the terms: rifles at sixty paces in ten days' time. In a cunning display, Wynkoop spent his free hours at public target practice, allowing folks to witness his deadly skill with a firearm. One of those bystanders was Margaret Cody, the aunt of the future Buffalo Bill. As a friend of the McClure family, Mrs. Cody felt compelled to warn McClure about Wynkoop's marksmanship, telling him, "Mackey, you're a dead duck if you face that Kansas Jayhawker!"[29] But McClure wouldn't listen to the outspoken Mrs. Cody. When the dueling day arrived, the two men stepped onto Stout Street in front of a gathering crowd. As their seconds paced the grounds and handed the men their rifles, Mrs. Cody elbowed her way through the spectators and jumped on top of a whiskey barrel. She cried out for the duel to stop. McClure's friends shouted their agreement. They had witnessed how Wynkoop could plug a target at sixty paces and pleaded with McClure to back down. McClure wavered. When faced with the reality of Wynkoop and his rifle, the Little Thunderer lost all his bluster. Meekly, McClure made his apologies to Wynkoop and called off the duel.

Years later, Wynkoop wrote, "Almost always there exists a certain state of society in newly settled countries which sometimes renders an appeal to arms absolutely necessary; In Colorado in 58-59 & 60 the 'Code' was universally recognized; and it would have required more nerve for a gentleman to refuse a challenge than to accept one."[30]

THE GENTLEMAN KILLER

On his way to Nevada, a young Samuel Clemens (pen name Mark Twain) traveled through the northeastern tip of Colorado by stage coach. As he bowled over the prairie, Twain wrote that the stage drivers could talk of no one else except a dark and determined desperado, Jack Slade. As one driver recounted, Slade worked as a wagon master and reprimanded a teamster for hindering the progress of the freighting operation. When the angered teamster drew his pistol, Slade calmly suggested they settle the argument with their fists instead. The teamster agreed and dropped his weapon. Smirking, Slade drew his gun and shot him dead. But that was just one version of the story. Another driver said that Slade and the teamster drank together like amiable frontier pards. When Slade bragged about his gun-slinging abilities, the drunken teamster laughed and taunted Slade to shoot him. Slade took the dare and killed him.

Wherever the truth lies in those tales, Slade gained a murderous reputation. He eventually took a job as a division agent with the stage company, which included a home station at Julesburg. Before the gold rush, the area's only resident was an old trader named Jules Beni (or Reni). He was said to be a Frenchman operating a trading post in the late 1850s at the California Crossing, a favored spot for Indians and immigrants to ford the South Platte River. As more people rode through the territory, the settlement expanded to fifty residents, with a store, a warehouse and a Pony Express office. The stage company dubbed their new route into Denver the "Overland Trail"

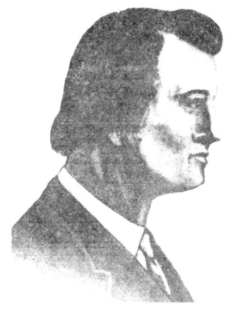

Drawing of Joseph A. "Jack" Slade. *Courtesy Denver Public Library Western History Collection, F-17835.*

and wanted to name the settlement "Overland City," but residents stubbornly referred to the spot as "Jules' burg," in honor of the area's first citizen.

For a short time, Jules supposedly managed the stage station but was removed on suspicion of running a horse-thieving ring. Angered that he was fired, Jules got his revenge by stealing the company's livestock anyway. Slade arrived to confront Jules, demanding that the old trader repay the company. After the argument, Slade assumed he had resolved the matter. But Jules was still fuming. Some stories say that while Slade relaxed in town, gambling with friends, Jules crouched outside the building with a loaded shotgun. Waiting and watching, Jules finally caught sight of Slade stepping into the doorway. Ambushing him, Jules jumped up and unloaded his shotgun into Slade. Jules ran off but didn't make it far. The manager of the express line, Ben Ficklin, apprehended Jules and determined to hang him. With no trees available on the barren plains, Ficklin tipped two wagons on their back-ends so the wagon tongues jutted up in the air. He then strung a rope between the tongues, fastened a noose to the taut rope and forced Jules's neck into the loop. Struggling and gasping, Jules begged for his life as the rope slowly choked the air out of him. When he turned black in the face and began to lose consciousness, Ficklin cut him down, warning him never to return.

Meanwhile, Slade slowly recovered from his wounds. Having ample time to plot his revenge, Slade returned to his duties with the express company the following summer. He vowed that if he ever found Jules, he would kill him on sight. In turn, Jules wandered the territory and kept a lookout for Slade, but unwittingly walked into a trap. Slade's friends captured him at a stage station in Wyoming, tied him to a corral post and sent for Slade. According to one of Slade's neighbors at the Horseshoe station, Slade took his vengeance slowly. First, he told Jules he was going to see how near he could shoot him without hitting his flesh. On the first shots, he grazed his hair and struck either side of his head. Helplessly tied to the post, Jules pleaded for Slade to have mercy. Coolly, Slade continued to toy with Jules, shooting him again and again without killing him. Then Slade struck the final blow—a clean shot between the eyes. After Jules slumped over, Slade cut off his ears as souvenirs. Stories say that Slade carried them in his pockets for months afterward. He would walk into a saloon and throw down a dried, shriveled ear on the bar, then demand, "Give me change for that!"[31]

All the Slade tales were fresh in Twain's ears as his coach rolled into a stage station. Inside, Twain sat down to breakfast with a group of ragged mountaineers and ranch hands, an uncivilized cluster of roughs, all save one who sat at the head of the table. He was a well-dressed gentleman of quiet manners, Twain wrote, and he enjoyed the man's company until someone addressed him as "Slade." Shivering, Twain tried to remain calm as the name sunk into his skin. Without realizing it, he was conversing with the most notorious gunman in the West, a man who had supposedly murdered twenty-six unfortunate souls, brutally and coldly. As the meal progressed, Twain tried to relax. Just when he doubted that the pleasant man was a dangerous desperado, Twain jumped when Slade reached toward him. Slade grabbed the coffee pot in front of Twain, and before pouring the last bit in his own cup, Slade politely offered to fill Twain's cup first. Even though he wanted it, Twain meekly declined. He wrote, "I was afraid he had not killed anybody that morning, and might be needing diversion."[32]

Luckily for Twain, Slade had not imbibed in enough whiskey that morning to cause any trouble. When drunk, he was a monster. After managing the Julesburg route, Slade was sent to a new station northwest of Laporte, which he named the "Virginia Dale" after his wife. While there, he terrorized the Front Range towns during his drinking bouts. Before long, the Overland Stage Company discharged him. His drinking only got worse, escalating into violent behavior when he moved to Montana. The good folks of Virginia City were so angered with Slade for riding his horse into saloons and shooting up the establishments that they formed a people's court and promptly lynched him.

SWIFT, SURE AND CERTAIN

On the banks of Cherry Creek, a fourteen-year-old boy pushed through a crowd of people. Irving Howbert had just arrived in June 1860 with his father, a Methodist minister turned gold seeker. In his memoirs, Howbert said he was beyond excited when his father agreed to take him west:

I had heard and read a great many tales of adventure in the Rocky Mountains and on the great plains, which told of the trappers, Indians and

*buffalo…My imagination had been fired by these stories to such an extent
that the region we would pass through on our journey and the mountains
beyond, were pictured in my young mind as a veritable wonderland.*[33]

A wonderland, Denver was not. The boy stood waiting as authorities led
an accused murderer up a slapped-together scaffold. The condemned man
solemnly asked a bystander to read his full confession. The letter admitted
the full details of his crime, how madness seized his brain when he argued
with a fellow prospector, grabbed an axe and wacked off his head. After a
prayer, the rope was adjusted and the drop released. For twenty minutes, the
man dangled and struggled until he was pronounced dead.

The reign of outlaws often prompted Denver citizens to take matters into
their own hands. When a serious crime occurred, townsfolk quickly selected
a judge, jury and executioner from the willing bystanders in town that day.
Having witnessed many of these people's courts, Byers said, "No, there were
no appeals in those days; no writs of errors; no attorneys' fees; no pardon
in six months. Punishment was swift, sure and certain. Murderers almost
always confessed their crimes."[34]

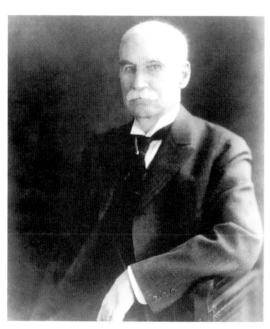

Portrait of Irving Howbert. *Courtesy Pikes Peak Library
District.*

The Howberts wanted out
of Denver. Fortunately, they
met a Methodist minister,
John Chivington, who asked
the Reverend Howbert to
help him establish missions
throughout the territory.
At thirty-nine, Chivington
was a frontier preacher
who moved from Illinois to
Missouri to Nebraska. As
a staunch abolitionist, his
outspoken nature and his
antislavery views caused
him some trouble in slave-
state Missouri. Members of
his congregation threatened
to tar and feather him if he

preached there again, but the fearless Chivington took the pulpit and laid two pistols on each side of the open Bible. He declared, "By the grace of God and these two revolvers, I am going to preach here today." His combative stance forever earned him the nickname, "Fighting Parson."[35]

Chivington convinced the Reverend Howbert to abandon gold seeking and instead travel toward Colorado City at the foot of Pikes Peak. The town was founded the year before by disappointed prospectors George Bute and Anthony Bott, along with former duelists Whitsitt and McClure. When deciding on a name, they looked at the rust-colored earth and called the city "Colorado" ("reddish" in Spanish). The founders also thought the name was ideal because they assumed the source of the Colorado River was somewhere above them. (The headwaters actually are in Rocky Mountain National Park.)

Like Denver, Colorado City sprouted without any organized government or laws, yet it didn't suffer the same blight of criminals and gamblers. To keep legal matters under tight control, citizens formed the El Paso Claim Club, men who managed everything from recording deeds to punishing claim jumpers, horse thieves and murderers. Howbert said that when a matter needed settling, all the men who could be gathered on short notice formed a tribunal. From this group they elected one to three men to act as judges. During a trial, the judges called witnesses, took evidence and then solicited a verdict from the bystanders for a vote.

Sometimes the El Paso Claim Club was a little too hasty in rendering decisions. In the summer of 1860, citizens witnessed a man gun down his business partner in the street. They apprehended the gunman and immediately formed a tribunal to put the man on trial for murder, even though the victim was still alive. They all knew the accused, Jim Laughlin, and his victim, Pat Devlin. The men had partnered in a ranching operation just north of the Garden of the Gods. Although they were both rather tough characters, as Howbert described them, Laughlin and Devlin were quite opposite in personalities and ambitions. While Laughlin had visions of expanding the ranching operation, the young Devlin expressed little interest in herding cows. He would often spend his afternoons in town boozing, womanizing and intimidating locals with his pistol handling.

After selling cattle in Denver, Devlin drank and gambled away the profits. His reckless behavior and spending spree infuriated Laughlin. When Devlin

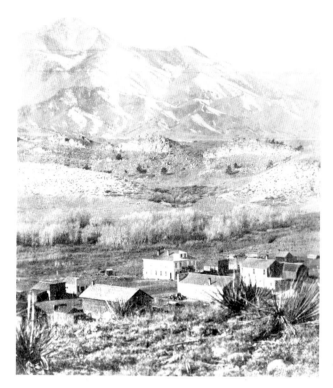

View of Colorado City in 1860, later annexed to Colorado Springs. *Courtesy Denver Public Library Western History Collection, X-7499.*

returned to the ranch, the two men argued bitterly. Both vowed to kill one another before Devlin stormed out. The next day, a determined Laughlin rode into Colorado City to purchase a double-barreled shotgun. When he spied Devlin strolling up the street, he took position between two cabins and waited. As the unsuspecting Devlin passed by, Laughlin stepped into the street and surprised him. Before Devlin could reach for his six-shooter, Laughlin said, "Mornin' Pat," and emptied both barrels into him.[36]

Immediately converging on the scene, the members of the El Paso Claim Club apprehended Laughlin and organized a jury in the street. Some examined Devlin's wounds and determined he would die, probably sooner than later. Not waiting for him to expire, the claim club proceeded immediately with the murder trial, listening to the testimonies of everyone who had witnessed Laughlin shoot Devlin. With all the evidence before them, the jury returned a verdict. They said that since Devlin was such a nuisance and no one much liked him anyway, their decision was "justifiable homicide."

As Howbert concluded, "This decision was somewhat premature, as Devlin lived more than two weeks after the verdict was rendered, but such things cut little figure in those early days."[37]

Notorious Mountain Charley

At the Gregory diggings in 1859, Horace Greeley met a young prospector awkwardly attempting to light a cigar in the wind. After inviting the youth into his tent, Greeley noticed how the lad's face was too comely and his voice too feminine. He quickly realized his guest was not a boy but a woman, none other than the veritable and notorious Mountain Charley. While in the mining camp, he found Mountain Charley, "smoking, drinking, swearing, and taking equal parts in the amusements of a crowd of loafers."[38] Her real name was Elsa Jane Forest, a young cross-dresser who said she had been married at fourteen and a widowed mother by sixteen. (In her later autobiography, she claimed to be married at only twelve, explaining that she had the "appearance of maturity" for her age.[39])

Another correspondent who knew Mountain Charley described her as a pert little woman of twenty-two who always dressed as a man but rarely bothered to hide her feminine sex. She was "always armed with a revolver or two in her belt and a long sheath-knife in her boot-leg," he wrote, "perfectly able and willing to protect herself in any emergency."[40] Like the men who surrounded her, Mountain Charley sought riches in the Pikes Peak region. But she didn't tell anyone what else, or who else, she hunted: the man who murdered her husband.

After some success at operating a bakery in the mining camp, Mountain Charley rented a watering hole in Denver called the Mountain Boy's Saloon, a dive catering to knife-wielding, gun-toting ruffians. Despite the shady surroundings, Mountain Charley knew the saloon was the perfect place, exactly the type of establishment where a lowlife she called "Jamieson" might enter. In years before, Jamieson had murdered her husband on a Mississippi River boat. Although tried and convicted, Jamieson was released on a technicality. The young widow was stunned. Determined to see justice, she cut her hair and adopted the manners and dress of a man, not just to gain employment but also to locate Jamieson while in disguise.

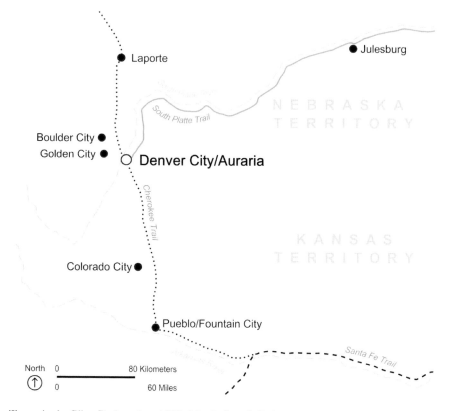

Towns in the Pikes Peak region, 1860. *Map by Sean Gallagher.*

She vowed that if she ever found him, "I would shoot him precisely as I would a mad dog."[41]

After placing her children with the Sisters of Charity, Mountain Charley worked as a cabin boy on a Mississippi steamer and later as a brakeman for a railroad. She spent her free hours in questionable establishments, places where shady gamblers and killers gathered to drown themselves in liquor. In her autobiography, which historians argue is partially fiction, Mountain Charley said she found Jamieson five years later in St. Louis. Following him down a dark street at midnight, she approached her husband's killer and revealed her identity, promising to send his black soul to the devil who gave it. Simultaneously, they drew their revolvers and fired, both missing. Cocking their revolvers again, they got off second shots, this time Jamieson hit her thigh and Mountain Charley hit his arm. When townsfolk ran in

their direction to investigate the sound of gunfire, the pair fled in opposite directions, both recovering to meet each other another day.

That next meeting happened in the spring of 1860, three miles from Denver. As she rode toward Golden along a narrow stretch of road, Mountain Charley saw a man approaching on a mule. She wrote that "he recognized me at the same moment, and his hand went after his revolver almost that instant mine did. I was a second too quick for him, for my shot tumbled him from his mule just as his ball whistled harmlessly by my head. Although dismounted, he was not prostrate and I fired at him again and brought him to the ground."[42]

But still, he lived. Cocking her revolver a third time, she leveled her pistol again, only to be stopped by hunters who happened by the scene. The hunters carried Jamieson back to Denver, with Mountain Charley trailing along and assuring them that she could explain why she shot the man. While he recovered at a boardinghouse, Jamieson confessed the whole history of their enmity, clearing her of any blame.

Mountain Charley returned to her saloon. Her barkeep, a man named Guerin, must have been quite charmed by the notorious smoking and swearing young lady. Guerin asked her to marry him and together they left the territory. Her quest to kill Jamieson was over. Shortly after she married Guerin, she learned that Jamieson had traveled to New Orleans and died of yellow fever.

CRITERION FOR ALL THINGS WICKED

The Cherry Creek dives were no place for a naïve greenhorn to expect a quiet drink and peaceful card game. Brutal thieves and killers overran the district, continuously threatening the property and lives of honest citizens. Most outlaws were drunk on Taos Lightning, a vile concoction of raw alcohol, burnt sugar, chewing tobacco and a pinch of gunpowder for extra kick. All were armed with pistols and knifes, and none would think twice about using them. No churches or schools yet existed, nor much of anything in the way of respectable business. By some estimates, one of every three buildings was a saloon or gambling hall that never closed.

With the influx of such ruffians, enterprising ladies set up business. As some stories suggest, the first prostitute to enter town was a dark-eyed

beauty, Addie LaMont. At nineteen, LaMont had married a young minister and joined a wagon train of gold seekers in 1859. But one night, after a week of traveling into the barren wilderness, her husband simply vanished. Along with him, a woman of "doubtful reputation" had also gone missing. The wagon train stopped to search for the itinerant pair, but no one found any sign of them. Everyone assumed the minister had abandoned his wife in favor of the other woman. (She later learned he was murdered.)

LaMont had no choice but to keep moving west with the wagon train. She maintained a stony silence for the entire trip, agonizing over how she could support herself. When their wagon train pulled into Auraria, the respectable minister's wife made a stunning proclamation: "As a God-fearing woman, you see me for the last time. As of tomorrow, I start the first brothel in this settlement. Any of you men in need of a little fun will always find the flaps of my tent open."[43]

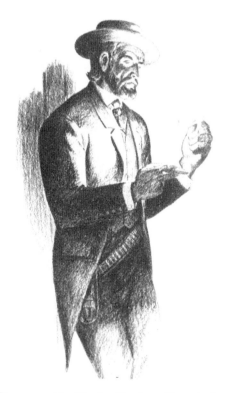

Denver gambler Charley Harrison. *Illustration by Ray Baker, originally published in* Rocky Mountain Life *magazine. Courtesy Denver Public Library Western History Collection, F-11767.*

LaMont even attracted attention from the Arapaho men camped in the area. Upon visiting her, a young chief was so taken by her beauty that he offered five ponies if she would become his wife. LaMont thought it was a joke and lightheartedly agreed to the bargain. When the chief returned with the ponies and a party of warriors, only then did she realize he was quite serious. Terrified, LaMont hid in a covered wagon. Fortunately, she had made the acquaintance of many young men in the territory, friends and customers who argued bitterly with the chief and told him LaMont had left the country.

Addie LaMont's business boomed in the growing settlement of mostly men. After recruiting other ladies, LaMont expanded to a two-story bordello on Arapahoe Street. Of all her clients, one captured her attention more than others: the notorious Southern gambler, Charley Harrison. In his early forties, Harrison rode into Denver on a stolen pony after eluding a Utah posse. Those who knew the handsome gambler said he usually dressed in black and always kept pearl-handled Colt revolvers at his hips. With his gambling earnings, he purchased the Criterion saloon on Larimer Street, considered one of Denver's finer establishments: a solid two-story frame building with hotel rooms on the second floor and a gaming room on the first.

Harrison quickly gained a nasty reputation around town. He had coldly killed a well-liked gambler, a former slave called "Professor Stark." He had also gunned down a drunk who pulled a revolver on his barkeep, Ned Wynkoop. After committing these murders without retribution, Harrison bragged that he planned to kill twelve men so he would have a jury of his peers in hell. But he wouldn't count the Mexicans and Negroes he'd already slain.[44]

As if murdering unsuspecting customers wasn't enough, Harrison further angered Denver residents when he helped a crazed killer named James Gordon escape justice. At twenty-three, Gordon was an amiable young man who had a promising future as a civil engineer. He unfortunately couldn't hold his liquor. After causing trouble back east, his parents brought him west to work a ranching claim outside of Denver. But the raucous gambling dens lured Gordon away from the bucolic life with his parents. Gordon eventually purchased a part ownership in Cibola Hall, a saloon and playhouse across from Wootton's saloon.

One evening, Gordon liquored up in Addie LaMont's place and tried to force himself on a girl. When she refused him, he drew his revolver and chased everyone out. A brave barkeep, Frank O'Neil, remained inside and tried to reason with the roostered gunslinger. Gordon turned his gun on O'Neil and shot at him. O'Neil dropped to the floor and tried crawling away, but Gordon continued to shoot. He hit him in the leg, breaking it in two places. The barkeep would never walk straight again.

Only days later, Gordon launched on another hellbender at the Denver House. At the gaming tables, he encountered Big Phil the Cannibal. As the name implied, Big Phil wasn't someone a sane or sober man might want to provoke. Described as gigantic in stature and repulsive in aspect, he was

labeled a cannibal while working for the government as a courier. After Big Phil and an Indian companion went missing in a snow storm, the troops at Fort Laramie assumed both had perished; but days later, the soldiers saw Big Phil approaching camp with something slung over his shoulder. The men asked what happened to his companion. Big Phil threw down a human leg and said that was all that was left of him.[45]

Big Phil's reputation didn't concern the intoxicated Gordon. The two men argued, and when Gordon pulled his revolver on the giant mountain man, Big Phil lunged for the door as lead balls whizzed by his head. Staggering after him, Gordon wandered out in daylight, waving and shooting his pistol. Terrified citizens ducked for cover. Gordon took aim at an unlucky dog that happened by, hitting it twice in the head before strolling into the Louisiana Saloon. Inside, a belligerent Gordon threw a bottle at the back of the bar, hitting glasses and more bottles. The loud crash sent frightened customers running toward the door.

Everyone escaped the ruckus except an elderly German, Jacob Gantz, who had just arrived from Leavenworth. For sport, Gordon took a swing at the unsuspecting man, sending him flailing backward. Injured but still lucid, Gantz pushed himself up and tried to make a run for it. Gordon easily caught him. Dragging him back inside, Gordon shoved Gantz to the floor and pounced on top of him. Gordon pressed the muzzle of his pistol to the terrorized man's head. As Gantz pleaded for his life, the drunken gunslinger laughed and squeezed the trigger. It didn't fire. Again, Gordon snapped the trigger two, three, four more times on empty chambers. Finally a ball blasted into the man's skull. With no one around to arrest him, Gordon sauntered away.

Hours later, the townsfolk decided to lynch Gordon, but none could find him. Charley Harrison tried to forewarn his friend and rode to his parents' ranch, but they hadn't seen him either. At the Cibola Hall, Harrison walked around the back and stumbled over Gordon, sleeping in the weeds. Harrison kicked him awake and gave him a fast horse, telling him to sober up quick and get out of town. Gordon rode like a demon to old Fort Lupton, where a posse of six men overtook him. Refusing to be captured, he spurred his horse east as the posse fired and lead peppered the dirt around him. In hot pursuit, the men finally shot his horse out from under him. Gordon took off running toward the dark river and burrowed into some bushes, successfully hiding himself until morning. When he realized the posse had given up the hunt, Gordon escaped.

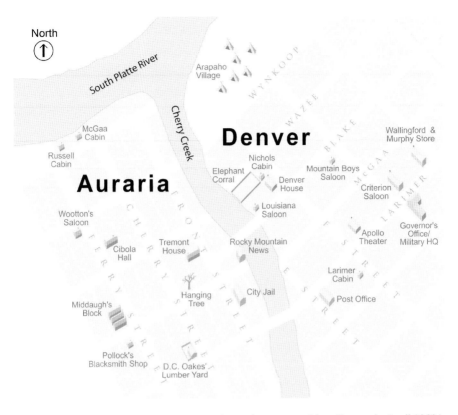

Street map of Denver in 1859–1869. (Auraria was incorporated into Denver in April 1860.) *Map by Sean Gallagher.*

The citizens of Denver demanded that someone go after Gordon, but few were willing to leave their homes and businesses to traverse dangerous Indian country. One man volunteered, a trusted citizen and real estate developer named William Middaugh. Receiving a warrant and an appointment as deputy U.S. marshal, Middaugh started off on a one-thousand-mile journey. Believing Gordon had traveled south, he rode to Bent's Fort, then east along the Santa Fe Trail. Tirelessly traveling day and night, he pushed farther into barren country. Just south of the trail, Middaugh finally surprised Gordon and captured him without much resistance. Middaugh decided to bring Gordon into Leavenworth where he could rest before taking his prisoner back to Denver. When he arrived, authorities in Leavenworth refused to recognize Middaugh's credentials, insisting Gordon must be tried there, not in Denver as Middaugh planned.

A week later, the judge decided to release Gordon on a technicality, saying that the crime was committed outside of the court's jurisdiction and Middaugh had no authority to arrest him. Gordon was free to leave, yet he could not step out of the courthouse without risking his life. A frenzied mob of German citizens pressed around the courthouse and threatened to lynch Gordon. They all knew the man he had killed back in Denver, Jacob Gantz, a beloved friend in their community.

To keep Gordon safe for the time being, the court asked Middaugh and several deputies to lead him away in chains to the military prison. Middaugh and the officers walked Gordon through a violent crowd. The Germans punched, kicked and tore at Gordon until he begged for Middaugh to let him die at their hands. But Middaugh kept on. The mob continued their assault, swinging fists, wielding knives and throwing ropes. In the frenzy, they ripped Gordon's clothes to shreds. By the time the bruised Middaugh got him to safety, Gordon wore nothing but his clanking chains.

Even though Gordon was technically free to go, Leavenworth officials kept him in prison. Middaugh refused to give up on justice, eventually winning the right to take Gordon back to Denver. After a tiring seven-day journey on horseback, Middaugh handed Gordon over to local authorities. Citizens quickly organized a people's court and sentenced him to hang. But like Gantz, Gordon also had many friends, one being Postmaster Park McClure, who acted as Gordon's defense. Before the scheduled execution, McClure circulated petitions to commute his punishment to banishment. The court held to their original ruling, and Gordon swung.

Three years after the Gordon execution, Middaugh took a trip east. As he rode along the Overland Trail, several of Gordon's friends jumped out from the bushes, surprised Middaugh and shot him dead.

The Pistol-Packing Press

Frontier journalism was not a job for the meek. Author Ambrose Bierce once wrote, "There is no recorded instance of punishment for shooting a newspaperman. The restrictions of the game law do not apply to this class of game. The newspaper man is a bird that is always in season."[46]

Politicians and Other Scoundrels

If William Byers was aware of the occupational hazards, it didn't deter him from speaking his mind. Byers hoped that Denver would settle into more peaceful ways, but after the Gordon incident and all the other shootings in town, Byers denounced the troublemakers in his paper:

The rowdies, ruffians, shoulder-hitters and bullies generally, that infest our city had better be warned in time, and at once desist from their outrages upon the people. Although our community has borne their lawless acts with a fortitude, very nearly akin to indifference, we believe that forbearance has ceased to be a virtue, and that the very next outrage will call down the vengeance of an outraged people, in a wave that will engulf not only the actors, but their aiders, abettors and sympathisers [sic] whoever they may be.[47]

Bison hunting party. William Byers is seated center-right, 1873. *Courtesy Denver Public Library Western History Collection, Z-2301.*

That direct challenge infuriated those cantankerous rowdies and ruffians, already soaked in rot-gut whiskey. As the Criterion gang vowed their revenge on Byers for such insults, Harrison shrugged off the editor's warning. He considered the remarks nothing more than an empty threat from a mild-mannered scribbler. Unfortunately, Harrison also chose to ignore the belligerent drunkards, as they loaded their pistols and stumbled out the door.

By that time, Byers had relocated the *Rocky Mountain News* office from the buckshot-riddled Wootton store to a newly constructed building in the dry bed of Cherry Creek. Byers said the location was politically advantageous because their office sat on neutral ground between Auraria and Denver, "now consolidated but still not entirely happy about the wedding."[48] After writing his scathing editorial, Byers was completely unaware that a mob led by gamblers Carroll Wood and George Steele was marching toward him.

The gambler gang forced its way into the printing office and accosted Byers. Wood shoved a pistol in the editor's face, grabbed him by the collar and demanded he go with them back to the Criterion. Then Wood heard a shout from above. Looking up, he saw the barrel of a rifle pointing down between the joists. One of the *News* employees had run upstairs and threatened to shoot the bully if Byers only gave the word. Remaining calm, Byers told him to hold fire. He would go to the Criterion peacefully.

When Harrison saw the mob marching Byers into the saloon, he raged at the kidnappers for their foolhardy actions. Not wanting any trouble with the editor, Harrison calmly led Byers through a back room, put a pistol in his hand and advised him to shoot any man who threatened him further. Byers knew the fight wasn't over. He escaped to the *News* office and told his employees to prepare for an attack. With him were John Dailey and his old *Cherry Creek Pioneer* rival, John Merrick, who gave up prospecting and sought employment with Byers.

Outside, Wood and his armed cronies took position behind a log building across the street. They silently kept watch for an open shot on the editor. While the men lay in wait, Steele mounted a horse and rode by the printing office, turning to take two shots through the *News* window. A lead ball whizzed past the editor's table but hit no one. John Merrick returned fire with his shotgun, hitting Steele in the back. Wounded, Steele managed to right himself in the saddle and continue riding.

The townsfolk heard the shots. Arming themselves, the people of Denver emerged from their homes and businesses to defend the printing office. A boisterous blacksmith, Noisy Tom Pollock, grabbed a shotgun and mounted a horse in pursuit of Steele. As Steele reeled his horse around for another attack, Pollock met Steele head-on. Charging their horses at full speed like jousting knights, the two men fired simultaneously. Pollock had the steadier hand. Steele took a load of buckshot in the chest and tumbled off his horse.

While Steele lay dead in the street, Wood and his fellow desperados fled the scene, all to be captured later that day. The Denver people formed a court and put Wood on trial. The jury agreed that he was guilty but couldn't reach a unanimous decision on the punishment. The judge asked the crowd to decide: hanging or banishment? With Wood's friends packing the room, the majority voted for banishment.

From that point forward, the employees of the *News* kept an arsenal of firearms in their composing room, each printer with a six-shooter at his side and a shotgun at his feet, while John Dailey always sported a Colt Navy

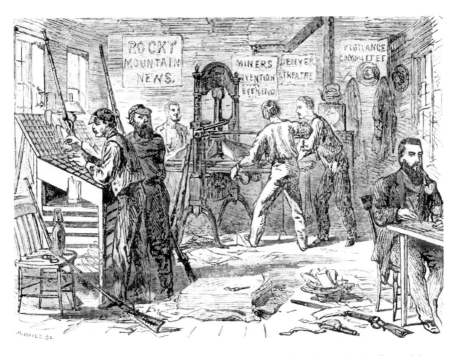

Rocky Mountain News employees work with firearms at their feet. *Illustration from* Beyond the Mississippi.

revolver at his belt. As Wootton said of his former tenant, "About the first question Byers asked of an employe [*sic*] in those days, was whether he could handle a gun to good advantage, and a printer who was handy in this respect, stood well with the proprietors of the paper, even though he had a multitude of shortcomings as a compositor."[49]

For the next eighteen years, Byers continued to stir up trouble in the editorial columns. Sometimes an infuriated reader would march into his office, waving a pistol or lunge at him with a knife. Even the ill-tempered Margaret Cody once stormed into the *News* building and horse-whipped the editor for printing slanders on her character. Fearing for his life, Byers's wife once said, "I experienced the horrors of seeing desperate men hiding behind a low shed waiting to shoot my husband as he came from the office. Nothing but a disguise changed every night prevented his assassination."[50]

In the spring of 1876, Byers faced the most determined of all his assailants. As Colorado prepared for official statehood, his name was bantered about as a potential candidate for the state's first governor. But his personal life was far from squeaky clean. Secretly, the still married editor had been intimately involved with a beautiful divorcée. When he considered making a run for office, he tried to quietly end the affair. The scorned woman wouldn't let him cast her aside so easily. She attempted to blackmail him by publishing his love letters in a Golden City newspaper, but he ignored her threats. She then determined to kill him. Grabbing her pearl-handled pistol, the woman followed Byers home and confronted him on the street. At point blank range, she fired—and missed. Again, she tried to shoot with her shaking hands, but Byers grabbed her arms and pinned them down at her sides.

All the while, Mrs. Byers witnessed the struggle from the upstairs window of their home. The society woman calmly walked outside, climbed in her carriage and rescued her cheating husband. As he dove on the seat beside his wife, his enraged lover continued shooting, never hitting anything more than the buggy cushions. The police later nabbed the gun-wielding woman and tossed her in jail. For one final blow to her former lover, she let the rival paper publish their personal letters anyway. Disgraced, Byers's political aspirations withered on the vine. He sold his newspaper two years later.

PICTURE OF A STATESMAN

In February 1861, delegates convinced a distracted United States Congress to approve their request for a territory, an area that encompassed its present-day state boundaries. Although many names were suggested, Congress settled on "Idaho," which someone mistakenly thought was an Indian word that meant "gem of the mountains." At the last minute, "Idaho" was crossed out, and "Colorado" was written instead. When folks back at Pikes Peak heard the news, the name confused them. No one thought that "Colorado" was a serious option, but Irving Howbert from Colorado City had a theory on the matter.

In his memoirs, Howbert wrote that Colorado City was a struggling town in 1861, with most of its citizens taking farming claims outside its boundaries. Residents thought that if they could secure the capital of the territory, their city might thrive again. The founders of Colorado City sent a representative to Washington with the specific intention of lobbying in favor of the name

The Second Territorial House of Representatives supposedly convened in this cabin in Colorado City, 1862. *Photo by Sean Gallagher.*

"Colorado" after their own town. They also wanted to push its southern boundary farther down into New Mexico territory to include Trinidad, so that Colorado City would be smack in the middle of the territory.[51] If true, the ploy to gain the capital worked. Several months later, newly appointed governor William Gilpin arrived in Denver. Gilpin began the immediate work of dividing the territory into districts and allowing the Pikes Peakers to elect representatives for a legislature. The first legislature voted to make Colorado City the capital, specifically because of its geographic center.

In July 1862, the second legislature convened in Colorado City. The legislators, their families and staff arrived by carriage, horseback and on foot. One of those newly elected officials was D.C. Oakes. After weary days of traveling and looking forward to a comfortable bed, Oakes and the other officials found a shoddy city with only one primitive hotel of such limited capacity that most everyone camped outside on the hard ground. The meeting place for the House of Representatives was a log cabin, twenty by fifteen feet, with rough boards laid across boxes where the twenty-six members sat. The thirteen members of the upper branch, the Council, assembled in a cramped hotel and tavern operated by a proprietor they called "Mother Maggard." Her hotel was nothing but a two-story log building where the men convened in the downstairs kitchen. When she needed to cook, Maggard shooed out the legislators and nagged them to gather wood for the fire.

With such rustic conditions, the gathering was the most unique legislative assembly in Colorado history. George Crocker, a representative from California Gulch, near present-day Leadville, actually walked 150 miles across South Park to make the session. Before coming to the gold fields, Crocker served as a city attorney of Chicago; but in 1862, his former colleagues may not have recognized him. Upon finding no accommodations, he wearily laid down his blanket at the door of the House of Representatives and fell asleep.

One of the representatives, Judge Wilbur Stone, described the slumbering Crocker:

> He had been mining and possessed no other clothes than those he wore at his sluice box in the gulch. His dress was a blue flannel shirt, trousers patched with buckskin, an old boot on one foot and a brogan on the other, an old slouch hat that he had slept in, the brim partly gone. His face was

blackened by the smoke of the campfire and furrowed by perspiration, his eyes hollow with fatigue and hunger, feet blistered by walking, hair tangled and beard yellow with dust; this was the picture of a statesman of the new west in the genesis of our generation.[52]

The spirit of the assembly took on a sour note when members of the House decided to pass a resolution to adjourn to Denver. When it reached the upper chamber of the Council, several legislators opposed the move. They had business interests in Colorado City and wanted to make it the permanent seat of government. Knowing that a vote required a quorum, the opposing members fled to a ranch south of town, halting the territorial legislature from further action.

To persuade the men to return, two councilmen traveled south and told the obstructionists that if they returned to Colorado City, they would also vote against the resolution of reconvening in Denver. The obstructionists took the bait and returned to the assembly in Maggard's kitchen. Locking the doors behind them, the duplicitous truce bearers switched votes in favor of moving to Denver. With that vote, Colorado City forever lost the capital, but its final location was not yet settled. For five more years, Denver and Golden battled for the capital, the legislatures alternating their sessions between the two towns. In 1867, they finally selected Denver as the permanent seat of Colorado government.

Chapter 3

Rebels and Ruffians

Just as Colorado began to take shape, the nation was ripping apart. In April 1861, news of the shots fired on Fort Sumter in South Carolina, and the first shots of a coming Civil War, stirred everyone into political vitriol. A majority of Coloradans supported the preservation of the Union, but a substantial number sympathized with the rebellion. In Denver, folks saw a patched-together Confederate flag waving over the Wallingford & Murphy store. Unionists shouted that the "rag of treason" must come down. Southerners demanded that the Stars and Bars remain. Over the boisterous yelling and shoving, a Union supporter scrambled up the building and ran down the Rebel flag, silencing the secessionists for the time being.

Compelled by a sense of duty for their native states, men abandoned their cabins and claims. In a reverse migration, they flooded the trails east to their home towns. General Larimer returned to Leavenworth, never to settle in Denver again. His son, William, stayed for a time but eventually trailed back with the rest of the men who planned to fight. Even the notorious Mountain Charley joined the cause. Stories say that she enlisted in the Union dressed as a man but infiltrated Confederate camps as a woman.

Because the sentiments around Denver clearly favored the Union, Dixie-born immigrants either laid low or made a stealthy exit. Dick Wootton sold his saloon and moved to a farm south of Pueblo, while the Georgian miners hid their gold in wagons and slipped out of the territory. The Russell brothers reached the Texas panhandle with $110,000 in gold bullion, but Union forces captured and detained them. Somehow, whether through bribes

or Masonic ties, Green Russell persuaded Union commanders to release them with their property and gold. The other miner from Georgia wasn't so lucky. John Gregory never arrived at his relatives' home in Alabama; his fate remains unknown. He simply disappeared.

For those left behind in Colorado Territory, grumblings between the political factions continued to fester in streets, stores and saloons. With all the turmoil, Governor Gilpin needed to organize a Union-backed militia. He sent his staff to visit homes and ranches, where they purchased a wide range of weapons, anything from double-barreled shotguns to ladies' pocket derringers. They weren't picky about the type of firearm, as long as it fired. Then Gilpin asked a respected Denver citizen and journalist, Samuel Tappan, to lead the recruitment effort. With a commission as captain, Tappan rode around the territory and raised a regiment of First Colorado Volunteers of mainly disappointed miners and frontier roughs, an unruly bunch that Tappan was charged with training.

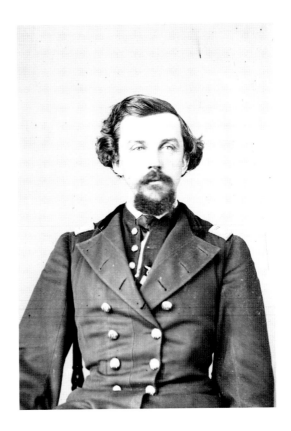

Portrait of Lieutenant Colonel Samuel Tappan. *Courtesy Library of Congress, Prints & Photographs Division.*

Yet unknown to the undisciplined volunteers, Confederates were filling their arsenals in Texas with plans to invade Colorado gold fields. Prepared or not, the Coloradans were about to fight a Civil War battle of their own.

His Jury in Hell

When Charley Harrison saw the cannon pointing through his saloon doors, he knew his days in Denver were numbered. For a short time, Harrison and his Southern friends had tolerated Tappan's rag-tag militia in the Criterion, especially since military headquarters sat across the street and the barracks lay directly behind his establishment. Throughout the summer of 1861, tensions simmered between the gamblers and the soldiers. The bored and rowdy recruits had no clear mission and no enemy to fight. In the saloons and all over town, the First Colorado caused havoc. As one historian described them, "They deserted at will, cussed out their officers with impunity, jayhawked the countryside for food to supplement army rations, and generally raised hell. Taps was merely a signal to head for the fleshpots in town."[53]

Trouble escalated when six liquored-up soldiers started a brawl in Addie LaMont's bordello. Half-dressed women screamed and scrambled into the streets. Hearing the commotion, Harrison and his well-armed cronies ran to Addie's defense. Wielding his pistols, Harrison quickly convinced the drunkards to exit the premises. But that wasn't enough for Harrison. He wanted to send the soldiers a stronger message. That night, he and a friend spotted a lone sentry guarding the barracks. They grabbed the soldier and dragged him into a dark corner, where they pummeled him into a bloody pulp. Harrison was arrested but later released under bond.

When Harrison freely walked back to the Criterion, the soldiers tried to force their way into his saloon. As gamblers blocked the entrance, the soldiers pounded on the doors until they burst through the barricade. They jumped the gamblers inside, the fight resulting in smashed tables and bloodied noses, with the outnumbered Southerners getting the worst of it. The soldiers exited the premises and assumed they taught the Harrison gang a lesson.

Later that night, as the soldiers paraded down the street, they heard gunfire coming from the upstairs windows of the Criterion. One soldier fell

to the ground, shot in the ankle. Another lost an earlobe to a lead ball. Captain Tappan immediately ordered a squad around the Criterion and moved a loaded howitzer in front of its doors. He yelled for the gamblers to give up their arms, then waited for local law enforcement to investigate the matter. In a few hours, they dragged Harrison away in chains, charging him with inciting a rebellion against the Union.

The Harrison trial stretched on for weeks, unusually long for those days. At the conclusion, Harrison was found guilty, fined $5,000 and sentenced to banishment from the territory. In his cool and defiant manner, the Denver gambler agreed to leave peacefully but not permanently. Harrison sold the Criterion and took the next stage coach for Missouri.

Following other Southerners like Park McClure, Harrison joined the Confederate army. He earned praise for leading successful raids into Kansas, but Harrison still wanted revenge on Colorado. He decided to take his raids a step further, convincing his superiors that invading the gold-laden region of the Rocky Mountains would be easy, the only hindrance being a few Indians scattered across the plains. Once he reached Denver, he promised to gather his Criterion cronies and take the city for a Confederate prize.

When Harrison began recruiting for a raiding party, old friend Park McClure was among the first to join. In May 1862, Harrison and McClure rode out from Missouri with a party of twenty cavalrymen, all wearing a disguise of civilian clothes. These men had extensive experience on the plains but were ignorant of an important development in southern Kansas. The Osage Indians, angry that Confederate guerillas had chased them off their lands, had aligned with Union forces.

Not far from the Missouri border, Osage scouts spotted Harrison and his company. The scouts stopped them and parlayed with Harrison through an interpreter. Harrison said they were just passing through and didn't want trouble. When the Osage scouts insisted they return with them to a Union camp, Harrison refused and promised to whip them. As their argument escalated into drawn pistols and gunfire, the Confederates dashed for a sandbar in the Verdigris River. More warriors poured over the hills. Armed with rifles, lances and arrows, the Osage quickly overwhelmed the Confederates. Within minutes, Park McClure took an axe to the head and died instantly. Harrison was shot in the face and tumbled from his saddle. Scrambling to his knees, he kept firing, only to be surrounded and killed. An

Osage scout grabbed his hair to take a scalp, but upon seeing his balding head, decided to scalp his bearded cheek instead.

Days later, Union troops visited an Osage camp and saw Harrison's beard-scalp hanging on a lance in front of a lodge. They also inspected the battleground and found Harrison's body, but it had no face. Other soldiers had no heads. When the news reached Denver that the former gambler and cold-blooded killer was dead, folks felt satisfied that Harrison had finally met his jury in hell.

THE DEVILS FROM PIKES PEAK

Before all the trouble at the Criterion, Ned Wynkoop had wisely quit his barkeep job. The den of Southern sympathizers was no place for a former Kansan and no place to earn a respectable living. He had won an official election as sheriff and married a pretty actress in town, Louise Wakely. When Tappan began organizing the First Colorado, Wynkoop resigned his position in local law enforcement and signed up for the volunteers. Well educated and well liked, he quickly received a promotion to captain of Company A.

Along with Wynkoop, other respected citizens stepped up to lead the First Colorado companies, including lawyer Jacob Downing, storekeeper Scott Anthony and the Fighting Parson, John Chivington. The governor asked Chivington to serve as the chaplain, but Chivington declined. Instead, he wanted to serve on the battlefield. Gilpin agreed and commissioned the ambitious Chivington as a major. For the other commanding officers, Gilpin promoted Sam Tappan to lieutenant colonel and sent him with three companies to Fort Wise, later renamed Fort Lyon. He then commissioned another lawyer in town, John Slough, as the regiment's colonel.

While the First Colorado mustered to Camp Weld two miles from Denver, Confederate troops began marching out of Texas. In the winter of 1861–1862, General Henry Hopkins Sibley led 2,600 men into New Mexico Territory, putting themselves within striking range of the Pikes Peak gold fields. The Confederate movements prompted the Union to request reinforcements from Colorado; in February, Colonel Slough prepared the troops to leave immediately for New Mexico. In frigid winter weather, seven

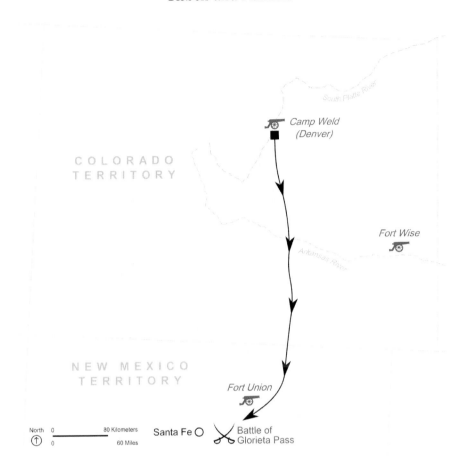

The three-hundred-mile march of the First Colorado Volunteers to Glorieta Pass in February 1862. *Map by Sean Gallagher.*

companies marched out of Denver, much to the relief of the citizens weary of their stealing and boozing. They continued in a snowstorm, exhausted and grumbling, as they neared the territory border. While en route, they received reports that the Confederates had soundly defeated Union troops near the town of Valverde and were quickly advancing on Albuquerque and Santa Fe. Despite his soldiers needing rest, Colonel Slough picked up the pace. The First Colorado pushed hard toward Trinidad, where Tappan's companies met them. The troops continued their forced march south, the 900 volunteers from Denver reaching their destination of Fort Union, New Mexico Territory, in an astounding fourteen days.

The New Mexico troops welcomed the arrival of the Pikes Peakers. The Texans had easily bowled over Albuquerque and Santa Fe, driving out Federal forces in both towns. Colonel Slough had no intention of letting Sibley get any farther north. Outranking Fort Union's acting commander and deciding to take charge, Slough disobeyed orders to stay at Fort Union and protect it. Instead, he led combined troops of 1,300 men from Colorado and New Mexico down the Santa Fe Trail. When they received reports of several hundred Confederates camped near the Johnson ranch, Slough sent Major Chivington in advance with 400 men.

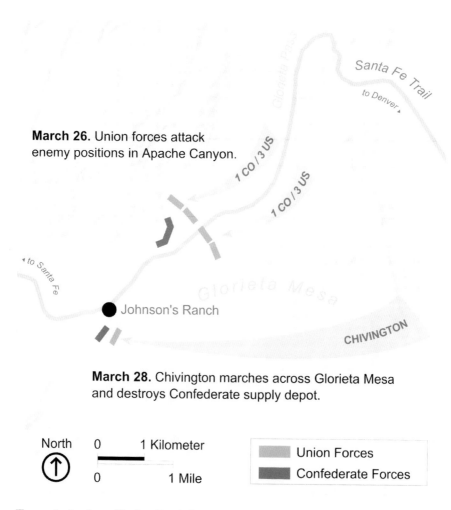

Two major battles at Glorieta Pass in March 1862. *Map by Sean Gallagher.*

Although Chivington had no formal training as a military commander, he seemed a natural at executing strategies. As his men tramped over the summit of Glorieta Pass and received the first fire from the Confederates, Chivington split the forces on each side of the divide. The infantry took position on the rim of Apache Canyon, including companies led by Captains Wynkoop, Downing and Anthony. The marksmen fired at the Texans from above, while Chivington and his militia charged at them from the canyon floor. Chivington reportedly rode about the battlefield with a pistol in each hand and a pistol holstered under each arm, making a giant target of his six-foot, four-inch, 250-pound frame. And yet, not a single bullet scathed the Fighting Parson.

A Confederate soldier wrote about the scene: "Before we could form in line of battle, their infantry were upon the hills, on both sides of us, shooting us down like sheep…They had no sooner got within shooting distance of us, than up came a company of cavalry at full charge, with swords and revolvers drawn, looking like so many flying devils."[54]

Two days later, after both sides rested and regrouped, Chivington secured yet another victory. Union scouts reported that over one thousand Confederates had left Johnson's ranch to march up the trail, leaving behind a supply train under light guard. While Slough and nine hundred troops faced the Confederates head-on, Chivington led his unit off the trail and toward the supply train. For several hours, the men hiked through dense thickets and over rocky ledges. When they spotted the supply camp, the Coloradans formed their plan of attack. Wynkoop and his marksmen quietly took position on an embankment above, unseen by the Texans below. The others lowered themselves down the canyon walls with ropes and straps, keeping their rifles in hand as they descended. Eventually, the crash of rocks and breaking branches alerted the guards. When the Confederates pointed their cannons at the Coloradans scrambling down the cliff side, Wynkoop and his sharpshooters picked off the gunners one by one. Chivington's ground troops charged into the camp and chased the Texans into the hills. As one captured soldier said, "Had it not been for the devils from Pike's Peak, this country would have been ours."[55]

While Chivington's men burned and destroyed the supply camp, Slough's men fought an intense battle until the Texans forced them to retreat up the trail. The Confederates relished their victory—but not for long. When they

returned to the supply camp that night, they found their wagons burned, their mules bayoneted and their guards missing. With no food and few choices, the Texans continued marching for Santa Fe. Sibley's demoralized troops later withdrew from New Mexico entirely, ending their Confederate campaign and their designs on Colorado gold.

After the victories at Glorieta Pass, Slough resigned his commission. Tappan declined a promotion and instead recommended the heroic Chivington to replace Slough. While Tappan returned to his command at Fort Lyon, the Fighting Parson soon became the highest-ranking officer in the territory. Wynkoop, Anthony and Downing all received promotions to major. Wynkoop stayed with his company in southern Colorado for another year. When he finally returned to Denver, he paraded through the streets with his company, as citizens greeted them with cheers. They presented Wynkoop with a fine horse for his valor in battle. Wynkoop was quite taken aback. He told the group that if he ever died for his country, he desired no nobler epitaph than "He was a Coloradan."[56]

Later, Colonel Chivington sent Wynkoop to command Fort Lyon. Chivington had already replaced Lieutenant Colonel Tappan as the fort's commander. Chivington and Tappan had disagreed over troop deployment along the Santa Fe Trail, and when Tappan disobeyed orders and deployed troops anyway, Chivington spitefully sent him to Fort Garland, a lonely outpost in the San Luis Valley. Once there, Tappan didn't have much excitement—not until the Bloody Espinosas arrived.

DEAD MAN'S CANYON

After two years in the mountains, Henry Harkens was sick of gold panning. At fifty-five, weary and disillusioned, Harkens abandoned the diggings and agreed to establish a sawmill with his friend, Murdock McPherson. In March 1863, Harkens made good progress on constructing a little cabin along the creek, a quiet spot where they would live next to the sawmill. One afternoon, McPherson and another employee named Bassett decided to quit work and take a walk down the canyon. Harkens, whom everyone fondly called "Uncle Henry," stayed behind to get supper started. He tossed down his trowel and strolled out the door in the fading afternoon light. On that fine spring day,

he may have been whistling to himself, glad to be settled in business with a good friend, glad to have the cozy cabin nearly complete. Whatever thoughts filled his head, they were his last. Not six feet from his cabin door, before he could grab an axe to chop wood, he looked up at the sound of hoof beats. Two riders approached with pistols drawn.

A mile down the canyon, a young Henry Priest helped his father build a road. They stopped to visit with McPherson and Bassett and discussed their progress on a path to the sawmill. As darkness descended, the Priests returned to their cabin for supper, while McPherson and Bassett turned back up the canyon for their own meal. Not long after, just as the Priest family sat down at the table, their door crashed open. It was McPherson and Bassett, gasping for breath and barely able to choke out the words. Harkens had been murdered, they said, and their cabin had been ransacked. But they saw no one. Now thoroughly frightened, they all imagined the worst: Indians on the war path or Confederate guerillas invading the gold fields.

Instead of running for help, they holed up in the cabin all night, waiting for an attack that never came. When morning dawned, the men shouldered their rifles and cautiously hiked up the canyon to investigate the scene. In an interview years later, Priest described how they discovered Uncle Henry sprawled on the ground. He had a gunshot wound in his forehead and knife gashes on his chest. The blood-thirsty killers had then grabbed the axe and split open his head from forehead to mouth. Then with the blunt end of the axe, they smashed each side of his head, so that his brains oozed into the dirt above his broken skull.[57]

Posses and cavalry set off in pursuit, but the killers continued to elude them. Wanton and vicious, they attacked ranchers and travelers along the major roads without leaving survivors to identify them. Finally near Fairplay, authorities found an eyewitness. Along a lonely trail, a man hauling a lumber wagon was ambushed. A lead ball struck his chest and deflected off a book in his shirt pocket, while his oxen bolted and carried the lucky man down the road. As he attempted to control his team, he looked back and caught a glimpse of two dark-skinned men emerging from the bushes—not Indians or Confederates but Mexican men.

Word got back to the posse. They pursued the two Mexicans toward Cañon City and discovered their camp along Four Mile Creek. Surrounding them, the posse fired on the unsuspecting men. One fell; the other fled down

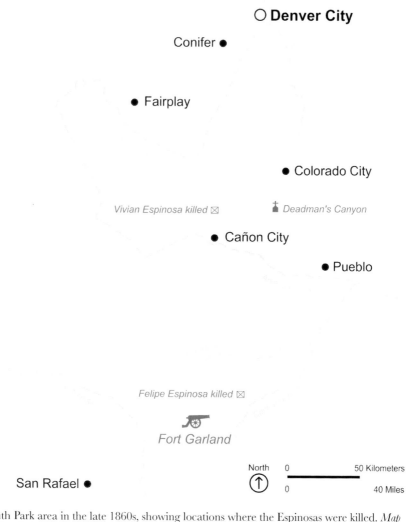

○ **Denver City**

Conifer ●

● Fairplay

● Colorado City

Vivian Espinosa killed ⊠ *Deadman's Canyon*

● Cañon City

● Pueblo

Felipe Espinosa killed ⊠

Fort Garland

North 0 50 Kilometers
 ↑
 0 40 Miles

San Rafael ●

South Park area in the late 1860s, showing locations where the Espinosas were killed. *Map by Sean Gallagher.*

a ravine and escaped. Back at the camp, the posse rifled through the killers' possessions and found stolen loot from murder victims, including gold-rimmed glasses that belonged to Harkens. They also found a memo book with several pages containing Spanish writing. Addressed to the governor, the pages described their plans for killing Americans. They also revealed their identity: the Espinosas. Authorities knew about these wanted outlaws,

Felipe and Vivian Espinosa. Vivian lay dead at their feet, but Felipe had slipped out of their reach.

Felipe managed to travel 150 miles back to his family farm in the San Luis Valley. Although well educated and devoutly religious, Felipe was a violent and troubled youth, with a vengeful hatred for white Americans. He once claimed that the Virgin Mary appeared before him and commanded that he kill one hundred white men for every member of his family lost during the Mexican-American War. His troubled ways continued into adulthood, when Felipe convinced Vivian to help him steal horses and rob freight wagons. In early 1863, troops from Fort Garland stormed into their home in San Rafael on the Conejos River. With guns blazing, the brothers managed to dodge the soldiers and flee to a hideout along a creek. When the soldiers left, the brothers returned to find their family crying and their home empty. The troops had cleared their home of all stolen goods and everything else they could carry. Felipe and Vivian then lost what remained of their senses and launched on a killing spree into the mountains.

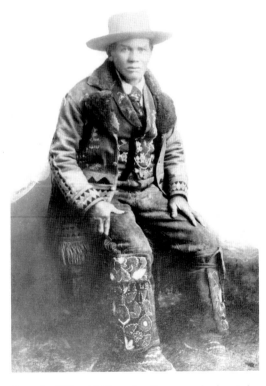

After Vivian's death, Felipe stayed in his hideout along a creek near San Rafael, all the while making plans to return to the mountains and continue killing. In the fall of 1863, he convinced his sixteen-year-old nephew, Jose, to join him. From the ridges of the Sangre de Cristo Canyon, the Espinosas planned to ambush and kill unsuspecting travelers along the trail. One day, as a man and woman rode in a buggy toward Fort Garland, Felipe and his nephew took shots

Portrait of Tom Tobin, a frontiersman who located and killed Felipe Espinosa. *Courtesy History Colorado (Scan #10027606).*

at them but missed. The Espinosas descended from the canyon and held the woman, while the man escaped on foot. The terrified man eventually reached Fort Garland twelve miles away and told his tale to the fort's new commanding officer, Lieutenant Colonel Tappan. Upon hearing the news, Tappan sent troops to retrieve the woman, then left by the road, and considered how best to catch the killers. Since the Espinosas had already eluded posses and cavalry, Tappan sought out mountain man and expert tracker Tom Tobin.

At forty, Tobin was an expert scout and guide. He was an average-sized man, about five feet, seven inches. With a tanned and leathery complexion from his years out in the Colorado sun, he had an almost Indian appearance despite his Irish blue eyes. When the reliable Tobin arrived at the fort, Tappan gave him only one order: bring back the Espinosas.

Tobin led fifteen soldiers into the mountains. The tracking required him to crawl under fallen timber, examine broken twigs and look for buzzards circling in the sky that might indicate butchered meat below. Upon spotting the Espinosa camp, Tobin checked that he had percussion caps secured in a thong around his neck, then put two .53-caliber lead balls in his mouth so he could quickly reload his Hawken rifle. He told the soldiers to remain silent while he stepped toward the killers. But no sooner did he give the command than he stepped on a twig himself. Its loud crack startled the younger Espinosa and allowed him time to jump for his gun.

Tobin took down the Espinosa boy. At the sound of gunfire, Felipe jumped from behind some trees. The soldiers fired at him and missed. Tobin managed to swiftly reload his rifle, later explaining, "I tipped my powder horn in my rifle, dropped a bullet from my mouth into the muzzle of my gun while I was capping it."[58] Tobin aimed and fired without hesitation, hitting Felipe in the back. The injured man crawled away and braced himself against a fallen log where he waved his gun and continued to shoot. The soldiers emptied their guns into him. As Felipe lay bleeding from multiple wounds, Tobin caught him by the hair, drew his head back over a log, then drew his knife and hacked off Felipe's head.

The next day, Tobin rode into Fort Garland with a flour sack tied to his saddle horn. Dismounting and untying the sack, Tobin strolled into Tappan's office. When the commander looked up, Tobin opened the sack and rolled

two heads at Tappan's feet, one with a scarred cheek and a grisly black beard, the other with a youthful face of a teenage boy. In a quiet, matter-of-fact declaration, he told Tappan that he had performed his duty. He had brought back the Espinosas.

By that fall of 1863, the "Bloody Espinosas" claimed to have killed thirty-two white men—all unsuspecting miners, ranchers and travelers. Like Henry Harkens, many were shot, axed and mutilated. The lonely grave of Harkens still sits on a grassy slope along Highway 115, in a gulch now known as "Dead Man's Canyon."

Henry Harkens's grave in Dead Man's Canyon (Highway 115), southwest of Colorado Springs. *Photo by Sean Gallagher.*

THE RAIDERS OF SOUTH PARK

Early in 1864, Coloradans began to relax. The Bloody Espinosas had been killed and a Confederate raid seemed less likely. As the Civil War dragged into its third year, Dick Wootton said that once folks realized the rebellion wasn't to be fought in the territory, "Northern and Southern men got along very comfortably together, notwithstanding their differences of opinion."[59]

Worries turned more to local matters, grasshoppers devastating the crops and heavy rains pounding the territory. The people living and working along the swollen creek banks assumed the waters would subside. Then late one May evening, a rumbling noise roused folks from their beds. A wall of water raged down both Plumb and Cherry Creeks, lifting trees, rocks, homes and people in a torrent of mud. At the *Rocky Mountain News* office, precariously

erected in the bed of Cherry Creek, the printers sleeping upstairs felt the building sway. Looking outside, they could see the floodwater plunging toward them. The men dove out of the windows, just before the wall of water lifted the entire office and smashed it into the banks of the South Platte River. Near Denver, the Byerses' ranch home sat comfortably on the east bank of the river until the raging waters cut a new channel and ploughed around the house to the other side. The frightened Byers family jumped on tables, as the river poured through their doors. To their rescue, soldiers led by Colonel Chivington rowed a skiff out to the home and brought the stranded family to dry ground. The next morning down in Pueblo, Dick Wootton said he arose to see a great bank of water racing down the Fountain Creek, the floodwater uprooting mature cottonwood trees and turning them into battering rams against homes and hillsides. Nine people were killed near Pueblo, another eight near Denver.

As towns along the Front Range dug out of the mud, new trouble brewed in the mountains. Near Fairplay, nine heavily armed men loitered around a

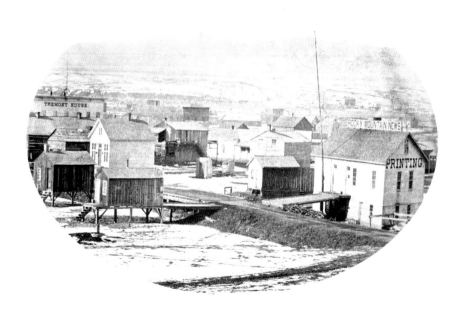

Rocky Mountain News office before the Cherry Creek flood of 1864. This is taken from the east bank, looking west. *Courtesy Denver Public Library Western History Collection, X-19429.*

stage station, a menacing bunch that caused anxiety among the employees and customers. One of those customers was William Berry, a news agent who delivered papers to the miners. As Berry enjoyed an early morning breakfast, the gang jumped into action when the stage coach rolled in from Buckskin Joe. Several men grabbed the lead horses to stop the driver, while others drew their pistols on everyone around. Held there, Berry watched as they robbed the only passenger of $400, broke open a treasury box with thousands of dollars in gold dust, ripped open the mail sack and axed the wheels of the coach to render it useless. Finally, the men took the personal belongings of the stage coach driver, Abe Williamson, who loudly protested that robbing the driver was bad manners even for thieves.

When finished with their plundering, the gang ordered everyone to remain at the station under pain of death and then spurred their horses on down the road. As a conscientious citizen, Berry wasn't about to let the robbers get away so easily. Mounting up, Berry trotted his horse down the road in hopes of warning others but unwittingly rode right up behind the robber gang. Unseen and hanging back, he tracked them throughout the day, waiting until morning to go after them again. At daybreak, Berry bumbled into one of the robbers on picket duty, Tom Holliman. The bandit quickly disarmed Berry and escorted him into the stage station where the thieves relaxed around a breakfast table.

The gang seemed jovial, talking freely with Berry about their plans to continue their raids. They bragged that they would grab Colorado gold and burn Denver to cinders, just as their Confederate hero, William Quantrill, had done to Lawrence, Kansas. Their loquacious leader toyed with Berry, asking how much money he thought Denver held. Berry calmly shrugged, telling him that Denver "was devilish dull, and they couldn't get anything worth going after."[60] The leader laughed at him. He already had spies in Denver, men who watched the banks and the Denver Mint. He knew Denver had plenty worth going after. After bantering with Berry awhile longer, the gang released him, not at all threatened; they didn't even consider his horse worth stealing.

Berry didn't believe these men were Confederate guerrillas, just unsophisticated land pirates. Still, they were dangerous. He rode hellbent for Denver, switching horses at every place he stopped and alerting the stage managers and ranchers to hide their stock and valuables. When he reached

United States Mint at Sixteenth and McGaa, later Market, in Denver in 1868. *Courtesy Denver Public Library Western History Collection, Z-5788.*

Denver, Berry gave a report to authorities and newspapers. Some citizens were alarmed, while others just thought his story was a hoax. Believing the raid an exaggeration at best, the *Daily Mining Journal* in Black Hawk editorialized that Confederate guerillas wouldn't be so stupid as to reveal attack plans to a hostage and then let him go.[61]

Whether dimwitted or just overly confident, the nine armed men continued on the road toward Denver, raiding at a leisurely pace, capturing horses, shaking down travelers, yet harming no one. By this time, both the cavalry and infuriated South Park residents rode after the gang. In just a few days, a posse of twelve citizens found the bandits above Conifer, their campfire serving as a beacon to their location. Surprising them, the posse fired down on the robbers, wounding one and killing another. The leader ran down a ravine and hid the loot in an abandoned mining hole, while

the rest of the gang scattered throughout the mountains. The former picket guard, Tom Holliman, rode all night to reach Cañon City alone. Exhausted, he stopped to rest at a ranch house but was discovered and dragged to Fairplay for questioning.

Under threats of a neck stretching, Holliman revealed everything. He explained that he was from southern Missouri and fled to Texas so he wouldn't be taken into the Confederate army. While hiding in Texas, Holliman met Jim Reynolds, the leader of their gang. Reynolds told Holliman and other draft dodgers how they could avoid service and get rich at the same time. He had prospected in Colorado and knew the territory, convincing them that raiding the area would be easy. Holliman said Reynolds wouldn't stop, that he was "ambitious of being a second Quantrill."[62]

After confessing all he knew, Holliman was forced to ride in leg irons with a posse of seventy-five men. They wanted Holliman to lead them to wherever Reynolds might be hiding, but the robbers had already fanned out across the territory. Jim's brother, John, and two others managed to elude posses and cavalry, apparently reaching New Mexico safely. Leader Jim Reynolds and several others fled down the Arkansas River, with cavalry hot on their heels. The river was high and wild with floodwater, forcing Reynolds's group to travel east until they could find a crossing. After constructing a makeshift raft, they forded the river twenty-five miles downstream of Cañon City and thought they were safely on their way to New Mexico. But Reynolds made the mistake of stopping at a ranch house. The rancher drew his gun and held them there until the cavalry arrived.

Soldiers escorted the five captured men, including Holliman, to a military prison in Denver. They handed them over to Colonel Chivington, then commander of the newly formed Third Colorado Cavalry. Chivington telegraphed military headquarters in Leavenworth, asking permission to shoot them if convicted. Although they had done nothing more than rob a few people, Chivington wanted the maximum punishment. In response, headquarters said he had no authority to carry out the trial or punishment. The ever-persistent Chivington eventually got permission to treat the Reynolds gang as prisoners of war. He ordered his soldiers to transport them to Fort Lyon for military trial.

In early September, the five thieves emerged from prison under heavy guard. As a company from the Third Colorado escorted them out of

Denver, citizens assumed they would never hear from that bunch again. But unexpectedly, the soldiers returned to Denver much too soon to have made the nine-day journey to Fort Lyon and back. Town gossips said that Chivington gave orders to execute the prisoners on the way to Fort Lyon, a place he never intended them to reach. In Chivington's defense, the *Rocky Mountain News* reported that the prisoners became abusive, and when they tried to escape, the soldiers shot them—possibly a story Byers wrote to preserve Chivington's reputation. Byers was indebted to the fiery colonel for rescuing his family during the Cherry Creek flood.

No one knows what really happened to Reynolds and his gang. Some accounts say that Chivington ordered their execution; others say that Abe Williamson, the former stage driver they robbed, was responsible for carrying out the punishment. Williamson had joined the cavalry and took charge of transporting the prisoners to Fort Lyon. Falling behind the large military escort, Sergeant Williamson led the prisoners off the main road and ordered his men to line up the Reynolds gang and shoot them. When the soldiers hesitated, Williamson drew his pistol and killed the prisoners himself.

Months later, a former Denver resident discovered the gang's demise. As Dick Wootton traveled north from Pueblo, he stopped to rest along the road. Noticing ravens circling overhead, he searched around the area until he stumbled on a gruesome sight.

He said:

> *We found there the skeletons of four men, bound with ropes to as many trees. The flesh had been picked clean from the bones, but a bullet hole in each skull showed how the men had met their death. Each skeleton stood in a pair of boots, which was all that was left about them in the way of clothing, and altogether this was as ghastly a find, along a lonely road, as one could imagine.*[63]

Since Wootton found only four skeletons, speculation surrounded the disappearance of the fifth prisoner. Rumors suggest that he managed to escape the firing squad and made his way down to New Mexico to rejoin Jim's brother. Forming another gang, John Reynolds continued his business of thievery. When a bullet ended his career, he made a deathbed confession to an outlaw friend. He said that Jim had buried their plunder above Conifer

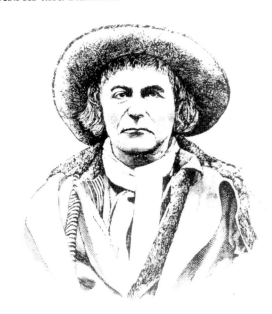

Drawing of "Uncle Dick" Wootton, shown in his mountain trapper attire. *Courtesy Pueblo County Historical Society.*

where the posse attacked them in 1864. The outlaw friend attempted to locate the buried loot but had no luck. To this day, no one is certain if the thousands of dollars in gold and greenbacks was ever found or if it is still waiting in an old prospector's hole on a South Park hillside. Hopeful hikers are still trying to find it.

Chapter 4

The People of the Plains

After a harsh winter and another wave of immigration in 1864, the Plains Indians found little game to hunt. More and more, they realized that the new white men were not their friends, not like the early settlers had been. Too many had poured over the prairie. The whites had claimed their land, scared off game and cheated them out of annuities promised to them in treaties. The Indians knew that many white men were still in the east, divided into two tribes in a fierce battle to annihilate each other. The warriors insisted that now was the time to raid settlements, but their elders wanted peace. The old chieftains understood the impossible numbers of whites and told their young braves that nothing could be gained by aggravating them. The war east of the Mississippi would end. The whites would be back in even greater numbers.

Defying the advice of their elders, several bands of warriors began stealing stock and firearms along the trails. When the ranchers and stage operators complained to military authorities, Major Jacob Downing led an expedition to track them down. But the raiders were experts at eluding the soldiers. Before the bluecoats arrived at the scene, the Indians deftly disappeared into the swells of the prairie. Finally, the frustrated Downing caught a lone warrior, a half-Cheyenne named Spotted Horse. To persuade him to reveal the whereabouts of the others, Downing tied him to a post, stacked firewood and bacon rinds at his feet and touched a match to the kindling. As the flames licked his toes, Spotted Horse decided to cooperate.

Spotted Horse led Downing to a camp in Cedar Canyon, north of the South Platte River. The infantry surprised the village, barraging the Indians and their

families as they took cover behind the rocks. When all was done, Downing claimed to have killed twenty-six Indians, but other reports suggest he killed two women and two children. Whatever the truth, Downing only managed to stir up anger and resentment among the tribes, not subdue them. Later, as the troops marched off for their next campaign down south, they left immigrants and settlers completely vulnerable on the ragged edge of civilization.

Just thirty miles southeast of Denver, the first whites were murdered in June 1864. Neighbors came upon the burned-out remains of the house and first found the body of the mother, stabbed and scalped. Her four-year-old daughter and infant lay nearby with their throats cut and heads nearly severed from their necks. The body of the father, also scalped and mutilated,

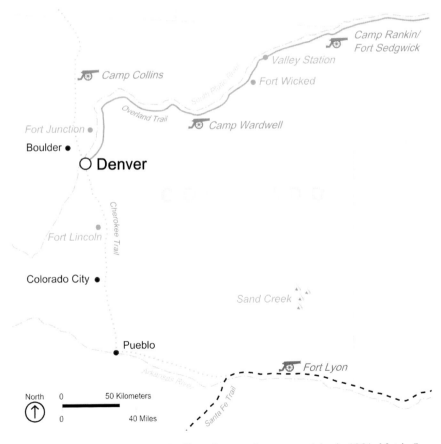

Locations of civilian-built forts and military forts on the eastern plains in 1864. *Map by Sean Gallagher.*

was found up the creek. It appeared that the Hungate family had put up a fight, probably when the Indians attempted to steal their stock and the father had shot one of them. In retaliation, the Indians fought back. But there were no witnesses, and no one could be sure what happened. The neighbors brought the bodies into Denver, placing the disfigured corpses side by side in open coffins for everyone to view. The horrific sight touched off rage and fear. In every town and every home, Coloradans talked of exterminating the Indians.

The Panic

D.C. Oakes didn't take any chances with Indians. After his election to the territorial legislature, he moved his family to Huntsville, near present-day Larkspur, halfway between Denver and what was supposed to be the new territorial capital of Colorado City. There, Oakes established another mill and ran the post office along a heavily traveled route. He often caught glimpses of Indians in the area, sometimes stealing stock, sometimes doing nothing at all. Predicting the worst, Oakes prepared for an inevitable war. In his spare time, he cut and stacked logs, constructing the foundation for what would serve as a defense against Indians. He proudly christened his project Fort Lincoln, but all his neighbors joked that the half-finished pile of lumber was nothing more than "Oakes' Folly."

After the Hungate murders, fresh reports of Indian raids filtered throughout the territory. Freight wagons were attacked, several teenage boys were killed and a stage station was lit up in flames. By late summer, young warriors virtually controlled the entire length of the Overland Trail, cutting off the territory from supplies. The white citizens feared another uprising like the one in Minnesota, when Sioux Indians had revolted against the government and killed eight hundred settlers in an attempt to regain their land.

The Colorado panic was described by Frank Root, manager of the Latham stage station, near present-day Greeley:

Wild rumors of Indian depredations continued to reach us almost daily— sometimes the reports were so thick that they came every few hours— recounting the brutalities being committed by the hostiles down the Platte

east of Latham. Some of the stories told almost made the blood run cold…I
never before experienced such feelings, and trust I never shall again.[64]

Outside of Denver, the only military outposts were in Fort Lyon (to the southeast), Camp Rankin (near Julesburg), Camp Collins (near Laporte), and Fort Garland (to the south)—far removed from the larger towns and with few troops to spare. Down the Front Range, the frightened settlers knew they had to protect themselves. In Pueblo, citizens erected a tower on a bluff above town, a defense structure pierced with rifle ports for easy sighting and shooting. In the Boulder and St. Vrain Valleys, the farmers organized a home guard and met each week for drills. When they could spare the time, they worked on a fort at the confluence of Boulder and St. Vrain Creeks, near present-day Longmont, which they called Fort Junction.

A few weeks after Fort Junction was complete, frontiersman Elbridge Gerry rode through the valley like Paul Revere, warning of a pending attack. As one of the first white settlers in the territory, Gerry owned a ranch on Crow Creek, near present-day Greeley, where he lived with two Indian wives. When Indian relatives warned him that one thousand warriors were preparing for an attack, Gerry alerted everyone along the road to Denver. In the Boulder and St. Vrain Valleys, all the families packed their wagons and fled to Fort Junction. They huddled behind the sod walls for that day and the next, with some of the women carrying pouches of strychnine poison in case they were captured. But the attack never materialized.

In August, an Arapaho chief named Left Hand (Niwot) visited the settlers near Fort Junction. Fluent in English and friendly with everyone he met, Left Hand often camped with his small band in the area. For several years, he and the settlers had lived harmoniously. Even after an ugly incident where Denver drunkards raped their women while the Arapaho men were out hunting, Left Hand restrained his warriors from a revenge attack. More than anything, he wanted peace. Before he decamped from the Boulder Valley, Left Hand told the settlers he would do everything he could to convince the young tribesmen to stop raiding.

He chose a good time to leave. Shortly thereafter, a military recruiter traveled through the valley, asking young men to volunteer for the Third Colorado Cavalry, a one-hundred-day assignment to fight and kill all Indians. Like the First Colorado Volunteers, many of these Third Colorado recruits

were ranchers, merchants and miners, not typical soldiers. George Bent had a harsh view of them: "This regiment had been hastily recruited from among the worst class of frontier whites—toughs, gamblers, and 'bad-men' from Denver and the mining camps…The men were not even in uniform, and they were alike only in one thing: they were all eager to kill Indians."[65]

The recruiters rode south to Huntsville and Colorado City, with Colonel Chivington in charge. Chivington visited the Oakes family and informed them that ten thousand Indians were united in a war against the whites. Chivington's report was a gross overestimate, but how were the settlers to know? In record time, every man, woman and child pitched in to complete Fort Lincoln. Working frantically with pistols at their sides, they heard rumors of Indians attacks all over the valley and read inaccurate accounts in the newspapers. The *Rocky Mountain News* reported that two young women, Hersa and Mattie Coberly, were killed at their ranch, when in fact the teenage girls were safe at the Oakes fort. For three weeks, thirty people remained at the fort. Fearful and cautious, the settlers would only sneak out for provisions under cover of darkness. When they could no longer see signs of Indians, they emerged from the confines of the fort to find all their ranches burned and stock driven off.

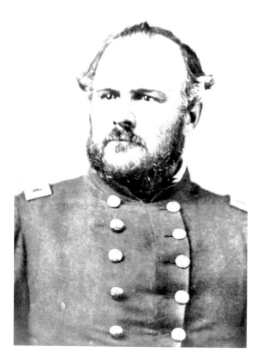

Portrait of Colonel John Chivington between 1860 and 1870. *Courtesy Denver Public Library Western History Collection, Z-128.*

In Colorado City, the citizens constructed a fortress, log walls that they piled around a prominent hotel. In the evenings, women and children gathered inside to sleep safely in the confines of the walls. Irving Howbert and other men volunteered for mounted guard duty. Only once did they spot Indians on the outskirts of town, but they did nothing more than steal horses.

When Chivington and the recruiters visited El Paso County, Howbert was determined to enlist. Two years before, his father had denied his request to join the First Colorado Volunteers during their march to New Mexico. He had missed the battle at Glorieta Pass and wasn't about to sit out another fight. By 1864, he was eighteen and ready to serve his country. This time, his father gave his consent. Since Chivington was a respected leader and a good friend, the Reverend Howbert believed his son would be in good hands with the Third Colorado.

THE CAPTIVES

With command of Fort Lyon that August, Major Wynkoop had problems. A party of Kiowa warriors had raided wagon trains and killed ranchers along the Arkansas River, practically within sight of the fort. He sent troops in pursuit, but the Indians continued to elude them. Adding to his frustrations, Wynkoop waited for the return of the fort's blacksmith, John Snyder, who was bringing his wife, Anna, from Denver. But no one had heard from them. Eventually, their worst fears became reality. The mutilated bodies of Snyder and his driver were found along the road; wife Anna was missing. Furious, Wynkoop vowed to carry out Chivington's orders: kill all Indians on sight.

Unknown to the military, a large band of Cheyenne, Sioux and Arapaho established a home camp to the northeast of Fort Lyon. But George Bent had no problem locating their base. That summer, George left his father's ranch to search for his brother Charlie and his mother's people. When he found them along the Solomon River in Kansas, George said it was the largest village he had ever seen, full of plunder from settlements and wagon trains. Old Indian men walked about the village wearing ladies' bonnets and veils. Young warriors wore fine shirts of bright colors and stripes, made from captured bolts of silk. War parties set out from the base camp every day, while other parties returned with captured goods, animals and sometimes white prisoners. In southern Nebraska territory, the Cheyenne Dog Soldiers had nabbed three women and three children, later bringing them back to the large camp.

Bent said the Dog Soldiers were responsible for most of the marauding:

> *The young men of this band were very wild and reckless, great raiders, and being hard to control were always in mischief. In this way they got the rest of the tribe into trouble. These young men would make a raid and get out of the way and the troops would come and stumble across some other band of Cheyennes and punish them for what the Dog Soldiers had done.*[66]

The Dog Soldiers earned their moniker for their unusual practice of selecting one warrior to stand at the forefront of a battle, pinned down like a dog. The warrior secured himself to what they called a "dog rope," a buffalo-hide sash with one end looped around his shoulder and the other end staked to the ground by a picket pin. Held there, the Dog Soldier fought off the onslaught of his enemies so his fellow warriors could take secure positions. Once tied to the dog rope, he couldn't leave unless another warrior pulled the picket pin.

While the young warriors raided settlements, Bent said the old chiefs called a council. Concerned that white soldiers would eventually attack, Black Kettle and other chiefs favored peace talks. Since Bent was American educated, they asked him to help write letters, one to the commander at Fort Lyon and one to their Indian agent. In the letters, the chiefs expressed their desire to make peace, their intent to release the white captives and their promise to convince their warriors to stop raiding. A medicine man named One Eye agreed to carry a letter to Fort Lyon.

As One Eye approached the fort, he raised his hands and waved the folded white paper at a lieutenant on duty. Although Wynkoop specifically ordered his men to shoot any Indian on sight, the lieutenant could not put a bullet in the old medicine man. He decided to take One Eye inside as a prisoner. Wynkoop was annoyed, but agreed to read the letter and listen to what One Eye had to say. Wynkoop summoned the interpreter, John Smith, the same mountain man who had greeted Wynkoop's party in 1858 and helped them jump the St. Charles claim. Fluent in Cheyenne, Smith translated for One Eye as he gave a speech about the plight of his people:

> *Our white Brothers have made war upon us…our women and children are scattered over the Prairie, fearing the approach of your troops; they fall down and die, there is wailing and mourning throughout our whole nation. We*

have tried to make peace, thinking that our white brothers would take pity on us, and that our Great Father when he knew that his Red Children were suffering and that they did not desire or wish to be at war with their white brothers would stretch forth his hand and say to his Soldiers—Stop.[67]

One Eye also said that Chief Black Kettle had traded with the Dog Soldiers for the white prisoners and moved his camp to the Smoky Hill River. They wanted to talk peace, and they wanted to talk trade. Wynkoop mulled it over. He felt compelled to do what he could for the white captives, even though his actions would be a direct violation of orders. When he informed his officers of his plans to meet with the Indians, they thought he had lost his mind. They tried convincing him to reconsider, that it was most likely a trap. But Wynkoop wouldn't be swayed. He wanted to meet with Black Kettle, and he wanted to rescue the captives.

Grudgingly, over one hundred men followed Wynkoop on a three-day trek toward the Smoky Hill River. When they neared the village, over six

Captives released to Major Wynkoop in 1864. *From left:* Ambrose Asher, Laura Roper, Isabelle Eubank and Danny Marble. *Courtesy Nebraska State Historical Society.*

hundred mounted warriors confronted them on the prairie. The threatening bunch whooped and shook their lances, acting as if they might kill every last one of them. Wynkoop ordered his troops into battle formation, then sent One Eye forward. The old medicine man assured the warriors that the bluecoats came for peace talks, convincing them to refrain from attack. Wynkoop then retreated a few miles away, made camp and waited.

The next day, the principal chiefs came to meet Wynkoop. Among the chiefs was Black Kettle, who had negotiated treaties in the past. Other curious warriors filtered in, some poking about wagons and fiddling with a howitzer, making the soldiers nervous. When the chiefs sat down in a circle, Wynkoop calmly walked to the center, handed his guns to an orderly, then made himself comfortable in the midst of scowling chiefs. One of his officers, Captain Silas Soule, watched the proceedings with astonishment. An experienced officer and frontiersman himself, he was amazed at Wynkoop's calm composure among the chiefs. Soule said that Wynkoop casually smoked on his pipe during a long and tense discussion, while his own teeth "were chattering all the while."[68]

With both John Smith and George Bent acting as translators, Wynkoop told the Indians he was not a big enough chief to negotiate peace; however, if they would release the captives, he would escort the chiefs to Denver to meet the new governor, John Evans. Thinking he had made an excellent deal, Wynkoop looked at the faces around him and saw nothing but angry glares. The Indians launched into their own speeches, some accusing Wynkoop of thinking they were stupid children, while others insisting that they should kill him on the spot. Black Kettle remained silent during the tirade, then serenely rose and held up his hand to squelch more outbursts. He told his people he considered Wynkoop a brave chief for coming to them. They should trust his word. Turning to Wynkoop, Black Kettle instructed him to break camp and travel south for several miles. He must wait there for news of their decision.

That evening, Wynkoop's men were near mutiny. They wanted to continue back to Fort Lyon, not sit on the open prairie where they might be slaughtered. Wynkoop held firm, insisting they stay. After a sleepless night where he began to second-guess his actions and berate himself for foolishness, the morning dawned to reveal the approach of Chief Left Hand, a man he already knew and trusted from their early days in Denver. With Left Hand was Laura

Roper, a sixteen-year-old girl who had been captured in Nebraska. Left Hand told Wynkoop that she was their first offering, and if Wynkoop would remain patient, he would return tomorrow with the remaining captives.

For another day, Wynkoop and his soldiers waited. As Left Hand promised, a messenger arrived the next morning and said that more captives were on their way. Wynkoop mounted up and rode a mile until he saw Black Kettle and his group riding toward him with two small boys on ponies. He greeted the boys, who looked fine but acted sullen. Then Wynkoop noticed another Indian approaching him with a small bundle. Inside the folds of the blanket, he saw a little blond head, two imploring blue eyes and two skinny arms reaching forward. He took the four-year-old Isabella in his arms and hugged her tight. In that moment, Wynkoop said that "such happiness I never experienced before, never since, and do not expect to in this world."[69]

When the soldiers returned to Fort Lyon, Captain Soule brought Laura Roper to the stationmaster's wife, Julia Lambert. Roper wore the same dress from the day she was captured, just rags by the time Lambert took charge of her. As she recovered, the teenager told Lambert her story of survival: how she was attacked while visiting a family friend, how she witnessed the murders of their families and how she endured the daily beatings and rapes in the Indian camp. She also revealed that two other women remained in captivity, Lucinda Eubank, the mother of little Isabella, and nineteen-year-old Nancy Morton.

But everyone wanted to know what happened to the blacksmith's wife, Anna Snyder. Roper revealed as much as she knew. In the village one day, an Arapaho led Roper into a lodge where she looked up to see Snyder's body hanging lifeless from the top of the lodge poles. Her calico dress had been cut into strips and twisted into a rope around her neck. The Arapaho said that Snyder had tried to escape and ran several miles over the prairie before they caught her. In despair, Snyder killed herself. Roper later told the other captive, Nancy Morton, what happened to the Snyder woman. Morton shook her head. She had doubts about the suicide, speculating that Snyder was not strong and agile enough to climb the lodge poles. (Yet later, when she was left behind as Roper and the children were rescued, a despondent Nancy Morton tried to hang herself in the same manner. She was grabbed before she could hoist herself up. Eventually they traded her for food and supplies near Fort Laramie, Wyoming.)

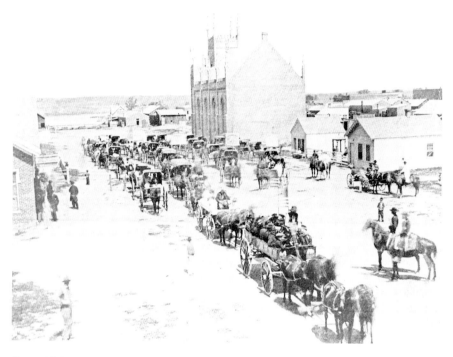

Peace chiefs and military escorts riding into Denver for the Camp Weld Council in 1864. *Courtesy History Colorado (Scan #10025737).*

In September, Wynkoop left Fort Lyon with Black Kettle and six other chiefs. He rode ahead with the children, reaching Denver to tell the governor that the Indians and their escorts were several days behind him. Governor Evans was not pleased. He did not want to talk with the Indians but had little choice when the excitement over the visit took hold of the town. As the military caravan approached days later, citizens gathered in their carriages and followed the wagon transporting the chiefs. With the Hungate murders still fresh in their minds, many town citizens were angry with Wynkoop for bringing Indians into the city. Some made threats to murder the chiefs and kill Wynkoop along with them. Others felt more conflicted. They knew Wynkoop acted rashly and defied orders, but they applauded him for rescuing the Nebraska children.

Despite the rescue, the captives suffered medical and emotional problems. Laura Roper, pregnant after her captivity, returned to her parents and had difficulty adjusting to society. One of the boys traveled back east to his grandparents but led a troubled life. The other boy died of typhoid

fever only weeks after arriving in Denver. Little Isabella was passed around between families, many who wanted to adopt her, but couldn't tolerate her night terrors and bizarre outbursts. The frail girl died in March 1865, only three months before her mother, Lucinda Eubank, was rescued, the last of the Nebraska captives to be released.

THE MASSACRE

The council with Governor Evans did not go well. Black Kettle tried to negotiate for peace, but Evans used the meeting to gather information about the tribes, their raids and their whereabouts. Chivington then lectured the Indians and told them to surrender at Fort Lyon. As Bent described the talks, "The chiefs remained puzzled by what Chivington had said and could not make out clearly what his intentions were. The truth probably was that he had already laid his plans…so in his talk he said nothing to alarm the chiefs or to disturb their belief that peace was soon to be concluded."[70]

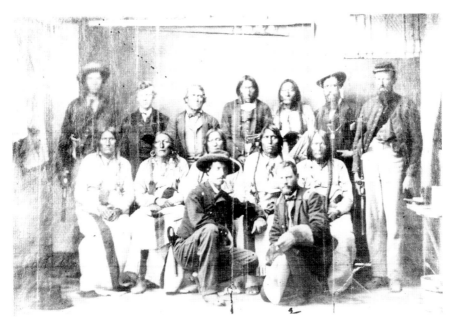

Camp Weld Council. *Kneeling in front:* Ned Wynkoop *(left)* and Silas Soule *(right)*. *Seated, third from left:* Black Kettle. *Standing, third from left:* interpreter John Smith. *Courtesy Denver Public Library Western History Collection, X-32079.*

Afterward, the chiefs returned to Fort Lyon and moved their village nearby. Wynkoop allowed them fort rations, again defying orders. In November, Major Scott Anthony arrived and relieved Wynkoop of his command. He told him to report to Fort Riley, Kansas, to answer for violating orders. Then taking charge, Anthony told Black Kettle to camp on Sand Creek, about forty miles to the north where they could hunt. Black Kettle was confused, but decided to trust Wynkoop's original word that the Indian village would be safe. Some of the Arapaho with Black Kettle did not trust Anthony, whom they called the "Little Red-Eyed Chief" for his persistent eye inflammation. Instead of leaving for Sand Creek, most of the Arapaho moved to another location, while Left Hand and his band followed Black Kettle. Also following the band was the interpreter John Smith, who wanted to stay with his Cheyenne wife and son.

Two days after Wynkoop left, Colonel Chivington, Major Downing and the Third Colorado Cavalry arrived unexpectedly at Fort Lyon. Among them was new recruit Irving Howbert, who said they rode on old plow horses that would shake them to pieces and carried outdated muskets that would send "a bullet rather viciously, but one could never tell where it would hit."[71] Fatigued and famished, the soldiers had no idea why they traveled to Fort Lyon. Chivington kept their mission a secret throughout the grueling trip. If the men thought they could rest at the fort, they were soon disappointed. Chivington revealed his plans to move again that same evening, all night in freezing weather toward the village on Sand Creek.

When Captain Soule learned of Chivington's orders, he confronted Major Anthony. He reminded him that Wynkoop had promised the chiefs protection. Anthony shrugged him off and told Soule that he and his men must ride with them that night. He further warned Soule to stay away from Chivington and not voice his opinions too freely. Other officers at Fort Lyon protested as well, some trying to persuade Chivington to reconsider, but the former preacher exploded with anger. Their mission remained unchanged: kill all Indians, take no prisoners.

That night, over seven hundred soldiers departed Fort Lyon on a forty-mile ride, stopping only when they saw the sun rising over Sand Creek and the village of 130 lodges.

At dawn on the morning of November 29, George Bent slept in a lodge at the Sand Creek camp. When he heard shouts and gunfire, he jumped up and

ran outside to see cavalry rapidly advancing and shooting down on them. The Indians scrambled in a state of half dress, the men and women arming themselves, the small children screaming. The interpreter John Smith emerged from his wife's lodge to investigate, then quickly ducked back inside when the troops fired on him too. Some of the Indians attempted to form a line of defense, but they had few weapons and little ammunition to make a stand against the cavalry. Calmly, Black Kettle called to his people not to be afraid, his words drowned out by

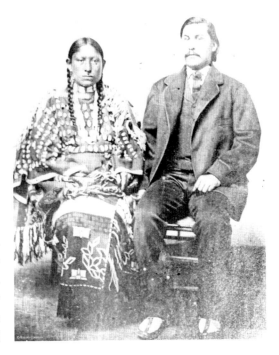

George Bent and wife Magpie (Black Kettle's niece) in Kansas in 1867. *Courtesy History Colorado (Scan #10025735).*

gunfire. Seeing bodies drop around him, the old chief finally grabbed his wife and ran after his people fleeing up the creek bed. His wife fell to the ground, bleeding and unmoving. Black Kettle assumed she was dead and kept running.

In the melee, both John Smith and George's brother, Charlie, were hustled over to the soldiers' side. Smith's son, Jack, initially joined the Indians in fighting but later gave himself up to the soldiers. George Bent took no chances with the bluecoats. He and the Indians grabbed their weapons and tried to make a stand on the sand hills. With gunfire hot around them, they abandoned their position and took cover in the creek. Bent saw the dry bed strewn with the bodies of friends and family, some dead, some too wounded to move. He continued running until he reached a high bank where the Indians were digging holes for cover. Just when Bent thought he reached safety, a bullet struck him in the hip. He tumbled into one of the holes, injured but not fatally.

Meanwhile, Howbert's battalion had successfully cut off the Indians from reaching one of their pony herds. Once they secured the animals, Howbert joined the ensuing fight. Until three o'clock that day, they took shots at the Indians holed up along the high banks of the creek. The Indians fired back whenever a soldier got in range. In the confusion of smoke and gunfire, Howbert said he couldn't distinguish between Indian men or women, because the buckskin-clad women fought alongside their men.

But not everyone was shooting. Defying the colonel, Captain Soule told his company that Chivington's order "was contrary to military law and contrary to the principles of civilized warfare."[72] His men kept their guns holstered and moved away from the action, watching in disgust as their fellow soldiers slaughtered over one hundred Indian men, women and children.

One of Bent's friends, Little Bear, described the carnage: "After the fight I came back down the creek and saw these dead bodies all cut up, and even the wounded scalped and slashed. I saw one old woman wandering about; her whole scalp had been taken off and the blood was running down into her eyes so that she could not see where to go."[73]

At dusk, the gunfire subsided. Black Kettle scrambled back to retrieve his wife's body and was astonished to find her still alive. She had been shot nine times but would recover. The other survivors crawled out of their holes in the hillside, with blood frozen to their half-naked bodies. They searched for their loved ones, finding many dead. John Smith walked about the field and identified many of the bodies. Among the dead he found the old medicine man, One Eye, who had spirited his family to safety before getting shot himself. Tragically for Smith, he later learned that some soldiers had started an argument with his son, Jack, who had already given himself up. The soldier drew his pistol and murdered his unarmed son.

While the soldiers ransacked what remained of the village, several Indian survivors caught ponies and rode to the Smoky Hill River for help. The others spent the night huddled together in a bitter wind on the open prairie. The elders gathered grass and lit little fires near the children, while their mothers piled grass over them for warmth. Freezing and unable to tolerate the cold, the surviving Indians left Sand Creek before sunup and headed north. Fellow tribesmen from the Smoky Hill rode out looking for them and pulled them onto their ponies. As they rode into camp, grieving relatives of Sand Creek victims gashed themselves with knives and vowed revenge. Both

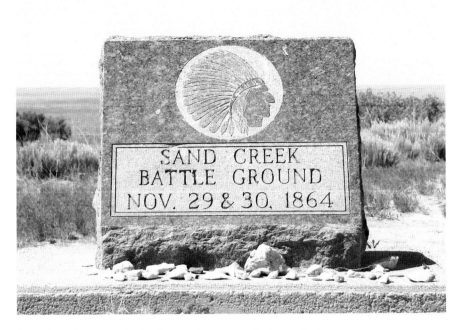

Sand Creek Massacre site, looking northeast. *Photo by Sean Gallagher.*

George Bent and Chief Left Hand made it to the village. Bent recovered from his wounds, but Left Hand was badly hurt. The Arapaho chief later died in the camp.

Back at Fort Lyon, Lieutenant Colonel Tappan had just returned from the East and was laid up with a broken foot. When the soldiers returned from Sand Creek, he was disgusted to learn about the massacre. Tappan said Chivington bragged about his accomplishments and "strutted about like a cock turkey, big in his own conceit."[74] In Denver, citizens lauded Chivington and his men as heroes for exterminating Indians. But it wasn't long before gruesome details of the battle reached the eastern press, angering readers all over the states. One witness to the massacre, Lieutenant James Cannon, said that every man, women and child had been mutilated in a horrible manner, with one soldier admitting that he had cut out an Indian woman's private parts and exhibited them on a stick. Still, local papers like the *Rocky Mountain News* continued to support Chivington's actions, maintaining he had performed his duty in punishing the Indians. With such conflicting stories, Coloradans were divided in their opinions. Most insisted that Chivington

was still a hero and didn't appreciate the eastern papers editorializing on the matter.

As Dick Wootton said:

> *Chivington was severely censured by the tender-hearted Eastern people, whose scalp locks were never in danger...I shouldn't wonder if the Indian lovers didn't succeed in persuading people back there, that the Comanches, Cheyennes, Apaches and Kiowas, were kind hearted, industrious and peace-loving creatures, while the white people of Colorado were merciless savages.*[75]

Echoing those sentiments, Irving Howbert also defended their actions at Sand Creek. He admitted that irresponsible men did scalp and mutilate the bodies of the Indians but excused their actions because some had lost family members during the Indian raids. Howbert firmly believed that if blame was to be assigned for the massacre, it should be heaped on an ineffective government. Lacking clear policies, the government failed to protect the rights of either Indians or white settlers.[76]

After the massacre, Captain Soule and others relayed the repugnant details of murder and mutilation to Wynkoop at Fort Riley. The news sent Wynkoop into a rage. He called Chivington an "inhuman monster" whose actions cost them peace with Indians.[77] In January 1865, Wynkoop returned to Fort Lyon to assume command, take testimonies from witnesses and inspect the battleground.

He wrote:

> *I visited the field of slaughter which was still covered with the ghastly remains of the victims, three-fourths of them were women and children, among whom were many young infants, there was not a single body but what had been scalped, while many both male and female had been mutilated in such a manner that decency will not permit to be recorded here.*[78]

Wynkoop's scathing report passed through military channels, finally reaching desks in Washington, D.C. His account helped launch several more investigations, including a Denver commission with Tappan serving as the chairman. By then Tappan and Chivington despised each other. Chivington

protested that Tappan was prejudiced against him, but there was nothing Chivington could do to remove him as chairman. The first to testify against Chivington was Captain Soule, later followed by Wynkoop and others. The commission wrapped up in April 1865, concluding with nothing more than a censure against Chivington, who had already resigned his commission.

Although the proceedings were supposedly kept secret, someone leaked what was said against Chivington. Many of the colonel's supporters were angry at Soule and others, making threats on their lives. Despite the heated environment, Soule wanted to remain in Denver. He had met the spunky Hersa Coberly, whose family operated a halfway house near the Oakeses' place. Soule accepted a position as Denver's provost marshal and married Hersa in April. Just weeks after the wedding and before the commission concluded, Soule was ambushed. As he walked home from the theater with his wife, he heard the sound of gunfire. Escorting Hersa home, he turned back and rounded a corner to investigate the noise. There he encountered a dark figure pointing a pistol at his head. The first shot missed Soule, allowing him time to draw his pistol. Both men fired, but the dark figure was a second quicker. Soule's shot hit his assailant in the hand, just as Soule took a shot to the face. The lead ball killed Soule instantly.

Authorities followed a trail of blood along Lawrence Street. They suspected a man named Charles Squires, who apparently had a bandaged hand and bragged that he had killed a man. Squires disappeared from Denver but was eventually captured in New Mexico. Escorting him back was Lieutenant James Cannon, who had been friends with Soule. Satisfied that he delivered the assassin, Cannon checked into the Tremont House for some rest. But only days later, Cannon also met with an untimely end. He died mysteriously in his hotel room, an apparent victim of poison. Meanwhile, Squires sat in the guardhouse awaiting trial. One night, while his guards inexplicably stepped away from their post, Squires slipped from his chains and out of his cell, never to be seen again.

Wynkoop and Tappan forever blamed Chivington for arranging the murders of both Soule and Cannon. But no one could prove the former minister had any involvement. Like Chivington, Wynkoop was both revered and hated after the massacre. Some admired him as a man who stood by his moral principles, but most others despised him as an Indian lover who endangered his men at Fort Lyon. The military brass respected Wynkoop's

bold testimony against Chivington and appointed him as an Indian agent. But over the years, the impossibility of keeping peace between whites and Indians wore him down. After some soul searching, he drafted a resignation letter in 1868 while en route to Fort Cobb, Oklahoma Territory. Wynkoop stated that he never wanted to be duped into thinking he could help Indians, nor did he want to be responsible for any more deaths. He wrote, "I certainly refuse to again be the instrument of the murder of innocent women and children."[79] The day after he sent his letter of resignation, General George Armstrong Custer led an attack on the peaceful Indians along the Washita River in Oklahoma. Black Kettle and his wife were found among the dead.

THE SIEGE

After the Sand Creek massacre, plains settlers worried about revenge attacks. They tried to reassure themselves that Chivington had whipped the Indians; and even if he did stir up a hornet's nest, long cold months lay ahead. They knew that Indians rarely waged war in winter, using the time to conserve their energy when food supplies were low. But that winter was different.

In December 1864, travelers and stage operators on the Overland Trail continued business as usual. The main thoroughfare into the Rocky Mountains still bustled with wagon trains and stage coaches. Stage stations and rest stops called "ranches" lined the trail every ten to fifteen miles from Julesburg to Denver. These long, low buildings were made of sod, hunks of hard dirt that stacked like bricks. The roofs were thatched with grass and mud, the windows open portholes and the floor hard-packed earth. One of the better ranches operated near present-day Merino, its proprietor an adventurous spirit named Holon Godfrey. In his late forties, Godfrey had traveled with the wave of prospectors in 1860. He knew that the most lucrative venture lay in selling goods and services along the road, not in panning for gold. Over the next few years, Godfrey built his business, buying and selling foot-sore animals and running a blacksmith to repair wagons. At his store, he sold food and hard liquor, which some of the stage drivers called "needle-gun whisky, guaranteed to kill a mile away."[80]

Godfrey brought his wife, Matilda, and family out to join him in 1863, including two daughters and a young son. For a year, they enjoyed operating

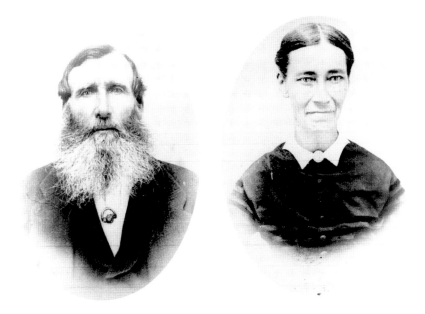

Holon and Matilda Godfrey, proprietors of Fort Wicked who held off a Cheyenne attack for three days in 1865. *Courtesy Overland Trail Museum in Sterling.*

the store and hosting travelers. Indians had stolen stock and caused mischief along the road but never enough to drive the whites away. Still, Godfrey took precautions. Like Oakes and many others, the hardened frontiersman prepared for the worst. Despite his pregnant wife begging for them to leave after the Hungate murders, he dug in his heels. First, he fortified his store and home with blocks of sod around the entire perimeter, six feet high and three feet thick. Next, he built a tower with open portholes that offered a view of the entire valley. For extra measure, he posted one of his employees on sentry duty to keep constant vigil.

While Godfrey guarded his fortress, the Plains tribes organized. The Dog Soldiers, Cheyenne, Sioux and Arapaho all wanted revenge after Sand Creek. Among them were George and Charlie Bent, who decided to turn their backs on white civilization and join in the retaliation. In January 1865, the Bents and one thousand warriors rode for Julesburg, an important hub on the stage route with stores, warehouses and a telegraph office. Up river sat the newly built Camp Rankin, a small fort with very few soldiers. The massive war party pitched their camp behind the sand hills, without anyone noticing their presence.

The next morning, the men painted themselves for war, including George and Charlie. When all were mounted and ready, several warriors raced over the hills and down toward the fort, taunting the soldiers to chase them. The trap nearly worked.

As Bent said:

> *They came nearer and nearer and it began to look like they would ride right into the trap; but, as usual, the Indians would not wait for the right moment, and some young men suddenly broke away from the main force and charged out of the hills toward the soldiers. The rest of the thousand followed them, as there was no longer any use in hiding. The soldiers saw us swarming out of the hills and halted at once, then began to retreat…Some of the cavalrymen jumped off their horses to fight on foot, but were at once surrounded; the rest of the troops, with their officer, galloped away toward the stockade, the Indians attacking them on all sides but not in strong enough force to cut them off and surround them.*[81]

Drawing of the Cheyenne attack on Julesburg and Camp Rankin in 1865. *Courtesy Denver Public Library Western History Collection, X-9612.*

Warriors also surrounded Julesburg down river. A stage coach barreled into town just as the attack began. The driver and passengers took off running along with the fleeing townsfolk. Some made a successful dash for the fort, running the entire mile to safety. Others fell into the hands of the Indians. Of the soldiers attacked, fourteen lay dead. After an easy conquest, the Indians plundered everything they could grab, including the paymaster's tin box from the coach. The warriors opened the box but were puzzled by the green paper inside. One took a tomahawk and chopped the greenbacks into little pieces, while another scattered the paper to the wind. Bent saw the money fly about and retrieved as much as he could. Then he walked inside a building where breakfast had just been laid out for the incoming coach passengers. For the first time in a long while, he sat at a table to enjoy a meal.

Down the trail, Charlie Bent and other warriors rode toward Denver and attacked a wagonload of travelers. They shot at its mules and drove the wagon off the road. Some passengers escaped to the river, others were killed. All that day, groups of warriors attacked from Julesburg to Valley Station, near present-day Sterling. For the unsuspecting whites, there was little military assistance with only a handful of soldiers protecting the road. Once the Indians finished their attack that day, the trail was quiet again—and remained quiet for an entire week. Stage operators and ranchers returned to their normal routines. Soldiers arrived to escort wagons and coaches. Then the Indians swooped down on them again. This time they moved up the river, closer to Denver and toward Godfrey's Ranche.

Godfrey was ready for them. On the morning of the attack, he sat perched in the tower with a view of the entire river bottom. When he spied a war party of Cheyenne and Sioux moving in his direction, he roused everyone from their beds—a crew of male employees, his wife and baby, 22-year-old Martha, 14-year-old Celia, and 6-year-old Cuba. As the adults took up arms, the war-painted Indians charged in to shoot, then quickly retreated. Over and over they charged, fired, and retreated. Godfrey and his men took aim out the rifle ports, careful not to waste ammunition until they had a good shot. Occasionally they hit a warrior and whooped when he tumbled to the ground. Matilda and Martha, a baby at their feet, occasionally fired out the portholes as well. Celia and Cuba kept the extra guns loaded and ready. They boldly held off the siege all morning; but in the distance, they saw a discouraging sight. Smoke billowed from the

American Ranche a mile away. The Godfreys knew it was over for their neighbors, the Morris family.

The Indians attempted the same strategy at the Godfrey Ranche. They set fire to the grass and aimed flaming arrows at the roof. But Godfrey had prepared for that, too. Having dug a well inside the walls, Godfrey scurried about with a bucket in one hand and rifle in the other, simultaneously shooting and soaking the grounds. The battle raged until dusk. During lulls, the men grabbed buckets of water to wet down the roof. Matilda and Martha caste lead balls in molds. Young Celia and Cuba put hats on broomsticks and moved them in front of the windows. By nightfall, the attacks stopped, but Godfrey never slept. He knew the Indians would return.

The next morning, the Indians charged in again. The Godfreys held them off for another day. Everyone was exhausted, not knowing if they could defend their home for a third day. Young Celia volunteered to ride to Camp Wardwell (present-day Fort Morgan). She was an expert rider and knew the hills well, but her father flatly refused to let his young daughter go. A man in their group named Perkins said he would attempt the ride. When darkness covered the valley, Perkins slipped out the gate and past the Indians. The next morning, several soldiers accompanied Perkins back to the Godfrey Ranche. They found 17 Indian bodies scattered about, but the Godfrey family and their employees were all safe. The Indians had retreated.

The warriors continued assaulting the stations and ranches along the Overland Trail for another two weeks, ending their bloody war by burning down Julesburg. When all was quiet again, the Godfrey place became famous as the only structure left standing on the Overland Trail, even receiving a mention in *Harper's Weekly*. But they could hardly rejoice. All their neighbors had been burned out. Many were killed. Some of the women and children had been captured.

Months later, the South Platte valley finally received adequate military assistance from the Galvanized Yankees, former Confederate prisoners earning their freedom by fighting Indians. Companies manned stage stations along the trail, effectively discouraging the Indians from further raids that year. At the Godfrey Ranche, one of the Galvanized Yankees noticed a sign over the front door that read "Fort Wicked." When the soldier asked why he named his place "wicked," Godfrey said, "Well, I guess the Sioux and Cheyennes know well enough."[82]

Chapter 5

Vigilantes and Villains

Seven miles east of Denver, four masked riders waited for the morning stage coach. As it approached from the west, the disguised men drew their pistols and halted its driver. Dismounting, one man flung open the door and accosted the frightened passengers. Looking about, he found the scoundrel he wanted: A.C. Ford, a well-known lawyer in Denver. He asked Ford to step out, then waved on the driver. The masked riders took Ford a mile from the road to a shallow slough. There they positioned him on the bank, facing the barrels of their shotguns. Ford offered no resistance. He knew who they were and why they wanted him. In fact, he was one of them. Calmly, Ford stood before the masked men without begging for his life. He simply asked his former friends to manage his affairs. The men nodded their agreement. Then they fired their shotguns into him, leaving his body where it fell. Days later, a search party discovered the decaying body riddled with buckshot. They found a note pinned to his coat. It simply stated that he was executed by the Vigilance Committee.

Every frontier community included some sort of vigilance committee, a group of prominent citizens who met to discuss criminal activity and take action when necessary. Often their membership was kept secret. In Denver, one hundred businessmen organized a clandestine tribunal to control the widespread crime in town, but such a large group couldn't be kept under wraps. To their embarrassment, the vigilantes discovered that some members like Ford conducted criminal activities of their own. As a lawyer, Ford defended horse thieves around town in 1860, often manipulating the system to get the bandits released while sharing in their profits.

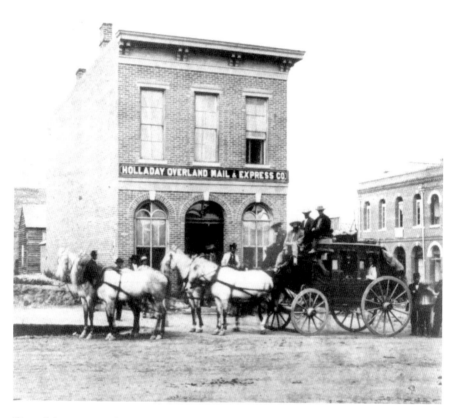

One of the stage coaches that operated from Denver in the 1860s. *Courtesy Library of Congress, Prints & Photographs Division.*

Around the territory, vigilantes either worked alongside peace officers or openly defied them. In some settlements, law enforcement became fragmented, imperfect, and often corrupt. Criminals, if caught alive, usually received some semblance of a public trial, typically with flimsy evidence or biased jurors. If a killer escaped justice unfairly, citizens sometimes formed a lynch mob, in effect becoming killers themselves.

In defense of these crime-controlling measures, William Byers editorialized:

> *The effect of the fact that our law machinery always screens rather than punishes criminals, is well shown up by these villains. They know they*

have nothing to fear when the critical moment comes. Some technicality of the law, disagreement of the jury, new trial, pardon, or loose jointed jail, will save them. The community would seem to have no way of protecting itself but to run well known ruffians down as it would wolves, and kill them.[83]

Not everyone agreed with vigilante justice, particularly when they discovered a body swinging down by the creek. But it was a necessary evil they had to accept.

I'll Die Hard

After the initial gold fever subsided, the worst of the crime died with it. Gamblers and desperados moved on, wherever they could find another gold strike and more greenhorns to swindle and rob. Denver citizens settled into a dull, comfortable life, yet it was only a brief respite. Later in the decade, another pack of thieves followed the railroad construction as it slowly inched its way across the northern plains, first to Cheyenne, then toward Denver. Once again, desperados plagued Colorado.

Between 1867 and 1868, horse thieves infiltrated the territory. Their leader, a murderer named L.H. Musgrove, committed a series of crimes from California to Colorado before organizing a horse-thieving ring near Denver. Musgrove continuously slipped through authorities' fingers, whether by outrunning them or by outsmarting the court system. Denver's city marshal, David Cook, described Musgrove: "He was a man of large stature, of shapely physique, piercing eye, and steady nerve, who might have stood as the original for the heavy villain of the best story…a man of daring, inured to danger, calm at the most critical times."[84]

Near the Cache La Poudre River, a posse led by U.S. marshal H.D. Haskell caught up with Musgrove in the autumn of 1868. When they dragged the notorious criminal back to Denver, everyone from California to Nebraska sighed with relief. Yet Denver citizens felt uneasy. Lowlife characters trickled into town, skulking about and causing trouble. Folks began to suspect the strangers were his underlings looking for ways to bust him out. Two of these men, Sam Dougan and Ed Franklin, were even brazen enough to visit Musgrove in jail.

In previous years, Dougan had killed a man in Central City and escaped from jail. Later, he came to Denver and was arrested for pistol-whipping a prostitute but again managed to escape. Eventually he fell in with Franklin, a ruffian who swore loyalty to Musgrove no matter how impossible the circumstances. But the two weren't terribly bright. Instead of forming escape plans for their leader, Dougan and Franklin recklessly stalked the town. They openly robbed unsuspecting men, including the city magistrate on Lawrence Street, relieving him of $135 in bills. When Dougan realized the magistrate recognized him, Dougan told Franklin, "Let's plant the damned old snoozer."[85] The magistrate stayed calm and persuaded them to refrain from shooting.

The pair fled to Golden where they whiled away the hours drinking and gambling in public saloons. Late into the evening, Franklin had enough fun and retired to his hotel room to sleep off the binge. Dougan continued raising hell. While sauntering down a city street, drunk and boisterous, Dougan and a companion spotted several armed men coming toward them. Among the men were Marshal Cook, Marshal Haskell and Jefferson County sheriff John Keith. In a split second, Dougan and his friend ducked inside a saloon. The officers pursued them, ordering Dougan to give himself up. From the door, Dougan fired on the officers. In response, the officers opened a fusillade on him, accidentally shooting and killing his companion, while Dougan fled down a dark street.

The frustrated officers wouldn't let the other bandit escape so easily. Having learned that Franklin retired to the Overland Hotel, the lawmen stormed into Franklin's room and attempted to secure irons around his hands and feet. Groggy but nimble, Franklin scrambled for his pistol and put up a vicious fight against the three law officers. He vowed that he wouldn't let them take him. "I'll die first," he said, "but I'll die hard."[86] Franklin got his wish. The lawmen shot him several times in the chest, killing him in his bed. The next day, Haskell returned to Denver with Franklin's body. He then deposited Franklin in an open box outside the jail, so all the residents could view his bloodied corpse and feel satisfied that one less desperado terrorized their town.

Meanwhile, Musgrove waited patiently in prison, still bragging that his gang would free him. Citizens remembered how the law had failed to serve justice on Musgrove before, prompting them to deliver justice for

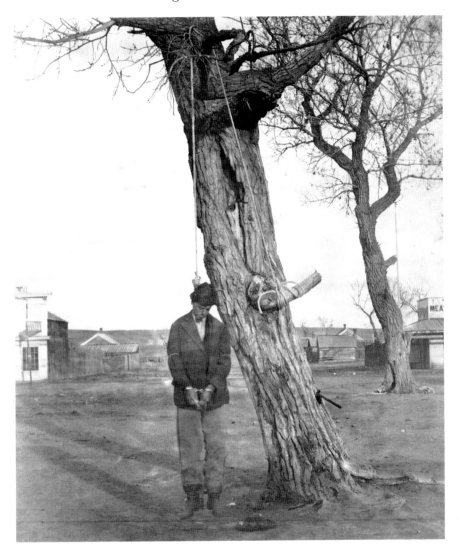

Sam Dougan, hanged by a Denver lynch mob in 1868. *Courtesy Denver Public Library Western History Collection, Z-5786.*

themselves. In the middle of the afternoon, a mob of vigilantes marched over to the Larimer Street prison. The vigilantes were all respected citizens: businessmen, lawyers, doctors, shop keepers. One vigilante asked the crowd to decide on Musgrove's fate: hang him or let him stand trial? It was all "ayes" for hanging. The vigilantes demanded the jailer step aside as they burst through the doors.

Inside, Musgrove heard them coming. Grabbing a large stick, Musgrove started swinging at the vigilantes. They attempted to grab him, even fired shots in the air, but Musgrove kept fighting them off. Eventually they dragged him outside, marched him down by the creek and shoved him in a wagon under the Larimer Street bridge. Musgrove searched the crowd for his outlaw friends. None stepped forward. Resigned to his fate, Musgrove remained cool. As vigilantes fastened a noose around his neck, he casually rolled himself a cigarette and asked someone for a light. Then Musgrove felt the wagon jolting from beneath his feet. Knowing that such a short drop would leave him dangling and struggling for ten minutes or more, he jumped high into the air as the wagon moved away. He came down hard against the rope, the fall breaking his neck instantly.

Days later, Marshal Cook caught up with Dougan near the Wyoming border. When he brought the bandit back to Denver, the vigilantes gathered around the Larimer Street prison and announced they would dispose of Dougan in the same manner as they did Musgrove. No one stormed the prison that day, but Cook knew they had formed plans. At dark, he grabbed Dougan from the cell, shoved him in a wagon and started off to the city jail on Front Street, a sturdier facility than the old Larimer Street prison. Along the way, a mob intercepted Cook and took control of the wagon, driving it under a leaning cottonwood. The vigilantes ignored Dougan's pleas for mercy as they secured the noose around his neck and drove the wagon out from under his feet.

The next morning, citizens living nearby awoke to see a body dangling from a limb. Disgusted, folks said they were tired of that cottonwood being used as the town's hanging tree. Someone cut down Dougan, then grabbed an axe and chopped the tree down to kindling.

HELL ON WHEELS

On a summer day in 1867, Captain Luther North relaxed outside a hotel in the latest incarnation of Julesburg. The town had moved twice in two years, once when it rebuilt next to Fort Sedgwick for protection and again when it crossed the river to meet the railroad construction. North was there to protect the Union Pacific from the Cheyenne and Sioux, warriors who

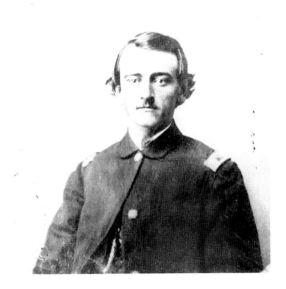

Portrait of Captain Luther North between 1860 and 1870. *Courtesy Nebraska State Historical Society.*

harassed the crews in an effort to stop the white man's progress. But after spending a day in the new Julesburg, Captain North may have preferred to take his chances with the Indians.

When the first locomotive chugged into Julesburg that June, a wicked bunch rolled in with it: Hell on Wheels, a foldable city of gambling halls, saloons and brothels that followed the progression of tracks moving west. The itinerant businessmen erected tents and flimsy buildings along makeshift streets, while hundreds of gamblers and prostitutes disembarked at the new Julesburg station. Overnight, the once quiet town of teamsters and telegraph operators transformed into a den of vice, earning it the dubious reputation as the Wickedest City in the West.

Outside the hotel, North and his pals watched a pimp named Slim Jim swaggering out a dance hall and waving his Colt revolver. The bystanders speculated on the events about to transpire. An armed man strolling brazenly down a street wasn't uncommon in this new Julesburg, but the sight sure meant trouble for someone. One said Slim Jim was after Swede Charlie for luring away one of his prostitutes. Another shook his head and said Swede Charlie was as bad as they come. Jim should be careful. They watched as Slim Jim burst through the doors of Charlie's place and slammed the door behind him. They heard two shots—pop, pop. In a moment, Slim Jim calmly

reemerged. He seemed fine, walking with perfect posture back toward his girls at the rear of the dance hall. No one noticed the blood oozing from his vest. Staggering and stumbling, Slim Jim fell face first in the dirt. He lay unmoving, dead at the ladies' feet.

The sudden transformation of Julesburg stunned many returning visitors, including journalist Henry Stanley, famed for finding the reclusive Dr. Livingstone in Africa. Stanley reported that most everyone seemed bent on debauchery, with the women more reckless than the men. He wrote how the prostitutes would glide through the streets in broad daylight, wearing skimpy costumes and derringers strapped to their waists.

As for the men, Stanley wrote:

> *I verily believe that there are men here who would murder a fellow-creature for five dollars. Nay, there are men who have already done it, and who stalk abroad in daylight unwhipped of justice. Not a day passes but a dead body is found somewhere in the vicinity with pockets rifled of their contents. But the people generally are strangely indifferent to what is going on.*[87]

By the middle of the summer, Julesburg's elected officials passed an ordinance requiring that all businesses take out a license or forfeit the right for protection from the law. The owners of the dens found the quaint little ordinance amusing. The determined citizens then organized a vigilante force to collect fees and maintain order, but this only managed to cause a riot. Nearly twenty people were shot in the protest against taxes. The town officials should have suspected as much. While they were trying to impose taxes on gamblers and prostitutes, they were dodging territorial taxes themselves. Since the new Julesburg moved three miles from the South Platte River, no one had yet determined if the town still lay in Colorado territory or had crossed into Nebraska. When tax collectors arrived from Denver, Julesburg officials insisted they were in Nebraska. When Nebraska collectors arrived, they insisted they were in Colorado.

After the riot, townsfolk pleaded with military officials at Fort Sedgwick for help, but the commanding officer said imposing martial law wasn't his responsibility. He didn't care if the gamblers killed each other, as long as they didn't bother his soldiers. With no aid from the fort, Julesburg officials raised the stakes. Using the printing press at the *Frontier Index*, the vagabond

newspaper that followed Hell on Wheels, they printed cards with threats and sent them to the worst of the pimps and gamblers. They warned the purveyors of vice to decamp in a hurry or risk turning up dead the next morning. After receiving the warning, some degenerates decided to save their necks and embarked on the next eastbound train. Other gamblers ran out of luck. Seven met their demise at the end of a rope.

Such extreme measures weren't necessary. When the rails reached Cheyenne in October, Hell on Wheels folded up and blew on down the tracks, leaving nothing behind but graves and garbage piles.

SCOUTS OF THE PRAIRIE

As the Union Pacific moved toward Cheyenne, a central line later called the Kansas Pacific progressed westward along the prairie from Kansas City. Although Hell on Wheels did not follow the central route, the railroad construction did spawn rough-and-tumble cattle towns all along its tracks. Town officials sometimes hired notorious gunmen like James Butler "Wild Bill" Hickok to maintain the peace, but beyond the city limits, law enforcement fell under the responsibility of the U.S. military and its scouts. Among the more famous scouts of the prairie was William F. Cody.

At age twenty-two, Cody was already an experienced hunter, fighter and guide. He had freighted goods to his aunt and uncle in Denver when only a boy, served in the Seventh Kansas Cavalry as a teenager and worked for the railroad, hunting buffalo. Out on the Kansas plains, he polished his marksmanship and earned himself the nickname "Buffalo Bill." When the railroad no longer needed him, Cody secured a position as an army scout and had distinguished himself by volunteering for dangerous courier missions. By 1868, he had traveled extensively around the ragged frontier from Leavenworth to Denver. He knew every gulley, creek and hill. The army needed men like Cody.

Unlike the enlisted soldiers, scouts were employed as private contractors who sold their services to the army. But because they served outside the military chain of command, scouts had the freedom for a bit of mischief and private profiteering. Sometimes they chased Indians without permission, sold captured Indian booty for extra cash or brought liquor into camp. Cody was

no exception. While serving as the Fifth Cavalry's chief of scouts for General Eugene Carr, Cody mired himself in trouble with Wild Bill Hickok, who then worked as a scout for the Tenth Cavalry. While their units temporarily joined forces, General Carr sent the two scouts on an expedition. Along the way, Cody and Hickok encountered Mexican teamsters with a cargo of beer intended to be sold at a nearby fort. The scouts relieved the Mexicans of their load and returned to General Carr's camp, selling the beer in pint cups to all the soldiers. The drinking fest resulted in what Cody called one

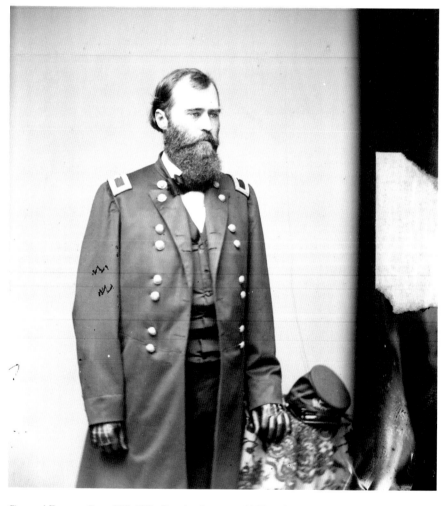

General Eugene Carr, U.S. Fifth Cavalry, between 1860 and 1870. *Courtesy Library of Congress, Prints & Photographs Division.*

of the "biggest beer jollifications it has ever been my misfortune to attend."[88] As they drank, a heated exchange erupted between the white scouts and some of the Mexican-American scouts. When Hickok called the Mexicans a bunch of "mongrels," the good-natured beer guzzling degenerated into a melee of swinging fists. The next morning, the hung-over Cody apologized to General Carr. He said that he and Hickok had "imbibed a few more drinks than we needed that evening."[89]

Carr didn't think much of Cody, not at first. But he soon learned the value of his tracking and hunting talents. To keep Cody occupied, the general sent him on a four-day hunting trip in brutal winter weather. Cody killed antelope and buffalo for the camps, at one point shooting over fifty buffalo in one day with his favorite hunting rifle, a .50-caliber Springfield that he fondly named "Lucretia Borgia." (The inspiration for the name originated from the title character in a melodramatic play of a murderous villainess, which he may have seen at the Apollo theater in Denver while working for his aunt and uncle.) By the end of the hunting trip, the continuous recoil of his rifle had so severely bruised his chest and shoulder, Cody needed assistance removing his jacket. Carr must have been pleased at the young scout's efforts. Not only had he secured enough meat for the scurvy-ridden soldiers, but he had also sacrificed the use of his arm, temporarily disabling him from lifting any more pints of beer.

In February 1869, the Fifth Cavalry moved to Fort Lyon, Colorado. At the fort, their most valuable animals were stolen, including General Carr's favorite horse. The general sent Cody and several scouts to follow the villains, whom they suspected were former packers named Williams and Bevins. Cody tracked them to Denver, assuming they would sell the animals at the public auction. He reached Denver in time to foil the bandits' plans, but Cody had a slight problem. He couldn't step in town without someone recognizing him, ruining his sneak attack. Besides his outspoken Aunt Margaret living there, his cousin, Olive, had moved back to town when her husband, D.C. Oakes, became a Ute Indian agent. Cody pulled his hat down over his face, hoping to avoid his relatives, and ducked into a hotel. He took a room overlooking the Elephant Corral, where he had a good view of the auction in progress. As he suspected, Williams led the stolen animals in the ring. Running down to the corral, he shouldered his way through the crowd and apprehended the thief, much to the surprise of everyone around him. Cody flashed his commission as United States detective and led Williams away.

Although Cody had secured Williams, the other bandit was still on the loose. And Williams wasn't talking. Hatching a plan, Cody took his prisoner three miles down the South Platte River. Stopping at the foot of a cottonwood tree, he told Williams to reveal the whereabouts of his thieving partner. The man denied having partners. To help jog his memory, Cody flung a rope over a sturdy limb and whistled to himself as he fashioned a noose from the other end. At the sight of the rope, Williams caved and agreed to lead Cody to his accomplice. The man was waiting for him at an abandoned house several miles downriver. Swiftly, Cody and his partners rode for the house, surrounded it and ordered Bevins to throw up his hands.

After capturing both thieves, the scouts started back to Fort Lyon during a spring snowfall. The first night, Bevins targeted the scout on guard duty and kicked him into the fire. The bandit grabbed his shoes and ran out over the frozen wilderness in the pitch dark. Cody woke and reached for his firearm. Williams jumped up and tried to run, but Cody hit him with the butt of his revolver and sent him sprawling to the ground. At daylight, Cody saddled

William F. Cody, taken when he was about twenty-one years old in 1867. *Courtesy History Colorado (Scan #10028112).*

his fastest horse and rode after the escaped prisoner. He found one of his shoes dropped in the slush and knew he couldn't have run far. Tracking him was easy. Bevins had scrambled over thorny prickly pears on a shoeless foot, leaving dribbles of blood like breadcrumbs. When Cody caught him twelve miles from camp, he said "a man who could run barefooted in the snow through a prickly-pear patch was surely a tough one."[90]

Cody may have been a good tracker, but he was a lousy jailer. Before he and his scouting partners ever reached Fort Lyon, Williams escaped along the Arkansas River. They deposited Bevins at Fort Lyon, but he too managed to escape. Although the mission was only a partial success, General Carr was pleased with Cody's efforts. The animals were returned and the thieves would probably never set a bloody foot in Colorado again.

The next month, General Carr led the Fifth Cavalry north to Fort McPherson in Nebraska. There, Cody met up with Luther North; his brother, Frank; and their command of Pawnee scouts. They were about to launch on another expedition, a more dangerous mission than tracking bandits. This time, they would engage the fiercest warriors on the plains: the Cheyenne Dog Soldiers.

Chapter 6

Cowboys and Indians

In the gold-rush years, Colorado's modest farms and ranches could not meet the demands for beef in the booming mining towns. But the scant supplies provided opportunity for ranchers outside the territory. Texas cattlemen like Charles Goodnight and Oliver Loving drove their Longhorns from their ranch in Texas, through New Mexico and into Colorado, blazing what would become the Goodnight-Loving Trail. Driving up Raton Pass and into Denver, they sold their beeves to eager livestock brokers and ranchers wanting to expand. Enterprising Coloradans like John Wesley Iliff increased their herds and claimed northeastern land with water holes and creeks, thus controlling the dry and otherwise useless land in between. Iliff operated one of the largest cattle operations on the northern plains. His ranch extended from Greeley to Julesburg, a vast amount of prairie where folks said he could travel a full week without ever leaving his own property.

As the cattle outfits expanded in the late 1860s, the Cheyenne and Arapaho were squeezed by Colorado ranchers from the west and Kansas settlers from the east, leaving only a narrow strip of hunting grounds in between. In desperation to feed their families, the tribes occasionally stole stock from ranchers. Cattle kings like Iliff and Goodnight understood their plight and allowed them to take what they needed. When confronted on the trail drives, Goodnight often cut out a few steers from the herd rather than risk the Indians stampeding his beeves.

During the late 1860s, the Plains Indians still tried to negotiate for peace and keep their hunting grounds. At councils, journalists like Henry Stanley

remarked how one of the Dog Soldier leaders, Tall Bull, stood out from the rest of the chiefs. Proud and defiant, Tall Bull shunned white men's ways. He would not wear bits of captured military clothing as many of his fellow warriors did, nor would he adopt white men's manners. Other chieftains might shake hands with the whites, but Tall Bull would only extend a pinky finger in a contemptuous insult. When the white men finished with their windy lectures at council, Tall Bull kept his comments brief. He simply stated that his people wanted peace, but if whites continued to claim their land, then war is what they would get.

After all the failed negotiations, Tall Bull continued raiding and punishing settlers in southern Kansas. One of his fellow chieftains tried to

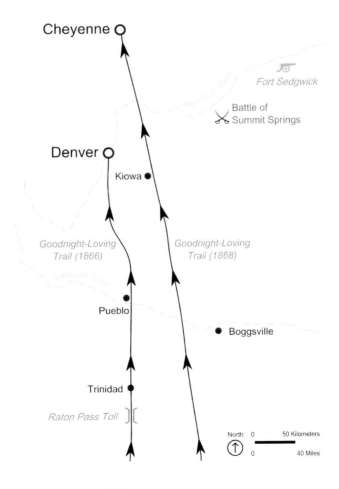

Both branches of the Goodnight-Loving Trail, 1866–1868. *Map by Sean Gallagher.*

persuade him to stop the attacks and submit to living on the reservation in Oklahoma territory, but Tall Bull refused. Later an army officer commented that Tall Bull and his people would never "make any peace that compelled them to settle down; they had always been a free nation, and they would remain so or die."[91]

THE LONE RANGE RIDER

The farther the ranches spread out from the mountains, the more dangerous the cattle business became. Those early days of the Colorado cattle industry were aptly described in *Century in the Saddle*: "In Denver and many of the other towns in the territory, law ended with the city limits. Outside of these towns there were marauding Indians, bandits, thieves and murderers…they roamed at large over an almost untracked wilderness. The only defense against them was a ready weapon and the ability to sleep lightly."[92]

Toward the end of the Civil War, young men stumbled into the territory looking for work, even the dangerous occupation of herding cattle alone on the prairie. In the Arkansas Valley, a tenderfoot named Dave Moody found his way into Pueblo. Broke and desperate, he was grateful to find employment as a herder. His base camp on the Arkansas River was a cramped shack constructed of cottonwood logs and a roof of thatched willow brush. There was no door, no floor and no fireplace for cooking. But it was grand to him. Moody loved his new profession, even though he had no other company but his pony, Old Poke, and the half-wild cattle. Roaming the prairie in peaceful solitude, he was elated to be monarch of all he surveyed, a man of chaps and spurs.

In his cattle domain was an orphaned buffalo named Pet, who made a general nuisance of himself. When Pet grew bored of his dull plains life, he romped and charged through the serene cattle, often causing a stampede. Moody wrote: "Then Poke and I had all the work we could handle rounding them up again, varied occasionally by taking part in the stampede ourselves; for when Pet saw us coming to the rescue he would take an impartial turn at charging us, and then we, too, would seek safety in flight."[93]

As Moody rode the range one afternoon, he heard a commotion of yelling women and barking dogs. Then he saw Pet dashing through the brush.

Arrows pierced his hide and angry Arapaho women ran close behind. They stopped when they saw Moody and pointed toward the destruction of their village. As Pet rejoined the safety of the cattle herd, the Arapaho women scolded Moody, threatening that their men would soon return and make short work of his stupid pet buffalo.

When tensions rose between Indians and settlers in 1864, Moody's employers warned him to be cautious. But he didn't lose any sleep over it. The Arapaho camping nearby had always been friendly, even after his buffalo stampeded through their lodges. When he noticed that the Arapaho had folded up their village and disappeared, he simply assumed they had left for other hunting grounds. That evening when he arrived back at his cabin, he saw that everything was gone: food, blankets, kettles, cups, spoons. Not only had the Arapaho packed their own belongings and left the country, they took all his provisions as well. Outside, he saw the prints of unshod hooves and moccasins, sure signs of a war party.

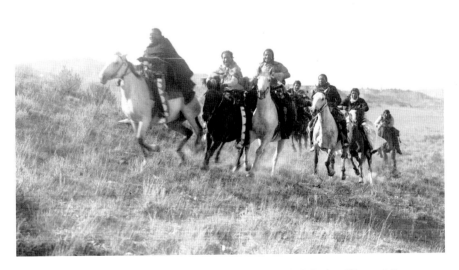

Cheyenne scouts returning to camp. *Courtesy Edward S. Curtis Collection, Library of Congress, Prints & Photographs Division.*

Remaining calm, Moody stopped to think about the best escape route. The nearest settlement was on the Huerfano River, a ranch operated by Charlie Autobee. The problem was, the tracks also led in that direction. He wouldn't be able to outrun warriors on Poke, a pony he said would mosey along at whatever pace pleased him. But Poke was gentle and quiet, certainly capable of sneaking by them on that moonless night. And if trouble should arise, he was well heeled with his two Colt .44 revolvers, a sawed-off Spencer rifle and a knife.

At dark, Moody set off on Poke, making a wide circle around the Indian tracks. He trotted carefully through the black of night and assured himself he would reach the Autobee ranch. Just when he congratulated himself on evading the Indians, he stumbled right into their night herder. The herder let out a yell, and Moody spurred Poke out of there.

He later described that moment:

> *For the next two minutes, it simply rained arrows. The night herder, riding a swifter running pony, was gaining on Poke and coming uncomfortably close. I turned in my saddle and fired back at him. The shot stopped the shower of arrows and the night herder slackened his pace. But I knew that by firing I had practically signed my death warrant. The Indians would never give up the chase until they got me.*[94]

As he feared, the noise woke the entire camp. His shot also frightened the Indian ponies. The ponies rushed in a wild stampede to the east, while Moody rode through them to the west. The warriors, thinking that an enemy was stealing their herd, rode off in the direction of their ponies. In the confusion, Moody reached the river. With no idea if Poke could swim the current, Moody decided to hole up in the thick underbrush of a gulley. The hiding spot was so dark he couldn't see his hand in front of his face. But he could hear hoof beats coming toward him. Moody held his breath, the minutes passing slowly. All the while, Poke never pawed or snorted to betray him. He lingered there for two hours. When all was silent again, Moody decided to venture out. He rode down the river bank and plunged into the water, Poke swimming like a beaver.

At daybreak, Moody safely arrived at the Autobee ranch, where Charlie Autobee gathered up his vaqueros and prepared for battle. The Indians

appeared the next day, but they saw the number of men against them and turned north into the hills. Moody credited his pony for saving his life, writing that "Old Poke was not the swiftest of cayuses, but he was by long odds the most trustworthy in any emergency."[95]

Wrong Turn Up a Cottonwood Limb

In the 1860s, the cattle business operated on the open range, with no fences to keep the cattle from wandering over the vast swells of prairie and no fences to keep outlaws from driving them off. With such easy pickings, cattle thieves were as numerous as the cows. The Arkansas Valley suffered the worst of the cattle thefts. From Boggsville to Trinidad, thousands of animals disappeared from ranches. Frustrated cattlemen like Goodnight kept a watchful eye on everyone he encountered along the trails, but the thieves were a slippery bunch, even for the former Texas Ranger.

After Comanche Indians killed his partner, Oliver Loving, Goodnight continued their cattle business and established a swing station in the Apishapa Canyon near Pueblo. In 1868, Goodnight moved his Texas herd over Raton Pass, the gateway into Colorado territory. There he was surprised to meet Dick Wootton, who had hired men to level a twenty-seven-mile road over the pass. At the toll station, Wootton told him the fee was ten cents a head for his thousands of cattle to pass through. Infuriated, Goodnight argued with him, but he wasn't about to turn the herd around and locate another road into Colorado. Forced to pay the price over a trail he and Loving had originally blazed, Goodnight vowed he would get revenge on Wootton.

As Wootton pocketed the money, he watched Goodnight's men urging the beeves over the pass and recognized one of the riders. Taking Goodnight aside, he informed the cattleman that he was employing one of the William Coe gang, a member of a notorious bunch of cattle thieves operating throughout the Arkansas Valley. When Goodnight and his crew safely trailed the cattle to his new ranch in the Apishapa Canyon, he paid the man his wages and told him to leave. (He should have been grateful to Wootton, but he continued to stew over the outrageous toll charges. On a later trip, Goodnight located a new route around Raton Pass fifty miles to the east and forever ended Wootton's monopoly.)

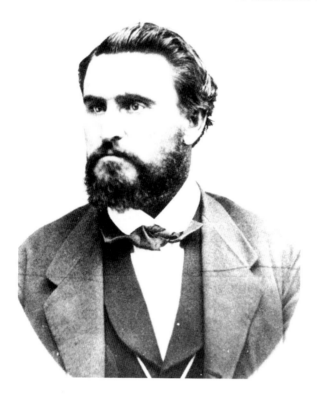

Portrait of Charles Goodnight, Texas Ranger and cattle king. *Courtesy Pueblo County Historical Society.*

Goodnight kept his eyes and ears open for any more trouble. He soon got word that the Coe gang was down in Trinidad, painting the town. Goodnight gathered up his boys and rode forty miles south, with the intent of capturing the bandits. But someone tipped off Coe, and all escaped before Goodnight arrived. Still, authorities were hot on their trail. In March 1868, soldiers captured Coe, along with twenty-three of his thieves. They hauled the gang into Pueblo; but even in the days of speedy trials, the townsfolk didn't like to wait for justice. During the night, a group of vigilantes broke into Coe's cell and dragged him out. They ordered Coe to make a run for it, but as a correspondent for the *Rocky Mountain News* described it, "He took the wrong road and brought up on a cottonwood limb, where he was found the next morning dead, with a placard attached to his person bearing the following inscription: Hung by Vigilantes. A warning to all murderers and horse-thieves."[96]

The end of William Coe didn't spell the end of the gang. In 1870, Goodnight encountered evidence of thievery again while traveling back to Pueblo with his new bride, a cultured woman from a prominent Southern

family. Meeting some teamsters who had been robbed, he immediately suspected the remaining members of the Coe gang. When Goodnight arrived in town, he reported the theft to the local vigilance committee and left the matter to them. He could not go after them himself. After the long journey by rail and stage, Goodnight worried about his delicate wife. She was exhausted and homesick, questioning why she let him take her into such rough country.

Goodnight brought his wife to the best hotel in town and assured her that once she got to know some people, she would learn to love Pueblo. The next morning, Goodnight awoke to see a grisly site outside the hotel: two bodies hanging from a telegraph pole. He hoped his wife wouldn't discover the scene, but a town lynching couldn't be kept a secret. The gossips told her all about the hanging. Later, she confronted her husband, demanding to know if the rumor was true.

"I understand they hanged them to the telegraph pole," she snapped at him. Having only been married a short time and not knowing how to handle such delicate matters, Goodnight stammered, "Well, I don't think it hurt the telegraph pole."[97]

TEXAS FEVER

Like the early Colorado population who hailed from Northern or Southern states, so too did the breeds of cattle. Settlers from the Northern states brought blooded shorthorns with them, called American cattle. At the same time, Southern drovers like Goodnight trailed Longhorns from Texas. Scrappy and wild, the Texas beeves were crawling with ticks and immune to most every disease. When the Longhorns passed through the eastern plains, the blooded American stock dropped like flies. Settlers who had worked so hard to bring their prized animals to the territory lost nearly all their livestock. No one knew what caused them to die, only that they got sick after mixing with Longhorns. They called the mysterious disease "Texas Fever."

The owners of American cattle decided to take action. In 1861, they pleaded with the new territorial legislature to pass a law prohibiting Longhorns in Colorado. They got their wish, partially anyway. The law was passed but without any way to enforce it. Authorities had enough trouble

with killers and ruffians to pay much attention to cows. Businessmen didn't support the local ranchers either. The swelling population needed more beef than locals could provide. As a compromise, Texas cattlemen wintered their animals along the Colorado border before driving them in. Although no one understood the disease, they knew that ticks carried it. And one winter on the freezing Colorado prairie was enough to kill the ticks.

Even with most Texans abiding by quarantine requests, some Southern drovers pushed through the territory anyway. In 1868, John Iliff had purchased cattle from Goodnight and requested that he bring them to Cheyenne for his contract with the railroad. Small ranchers worried that the influx of Longhorns would infect every herd from Pueblo to present-day Greeley. Near Cañon City, twenty armed men met Goodnight and his crew as they approached the Arkansas River. With shotguns in hand, they informed Goodnight that he couldn't bring his stock any farther. Not one to be intimidated, Goodnight told the settlers, "I've monkeyed as long as I want to with you sons-of-bitches," then ordered his crew to slide their rifles on the front of their saddles.[98] With their hands on their weapons, they plunged into the river and passed by the furious settlers. One of Goodnight's men later said, "If they had done a thing, we would have filled them so full of lead they'd never have got away."[99]

The continuing conflicts between Coloradans and Texans peaked in 1869. As the Kansas Pacific Railroad neared the eastern plains that year,

Cowboys on the Iliff ranch in northeast Colorado, with a chuck wagon, which was invented by Charles Goodnight. *Courtesy Library of Congress, Prints & Photographs Division.*

Colorado ranchers worried that more Texans would drive their Longhorns into Colorado for shipment. Concerned ranchers organized a cattle association with the explicit purpose of keeping out the Texas beeves, but they could do little to stop them. That April, two drovers pressed through El Paso and Douglas counties with two thousand Longhorns. While camping near Kiowa one night, Texans John Dawson and his partner, Joe Curtis, suddenly awoke to the sounds of gunfire. Before they could grab their pistols, all two thousand cattle stampeded across the countryside, some dropping from the stray bullets. Terrified and disoriented in the darkness, the herdsmen thought that Indians had attacked them.

The next morning, as the Texans rounded up the cattle, they asked local ranchers if they had seen their lost animals. Some settlers confessed that not only had they seen the animals, but they were the ones responsible for the stampede. They further warned Dawson and Curtis to leave the country, or next time they wouldn't stop at shooting just the cows.

Both the *Rocky Mountain News* and *Colorado Chieftain* scolded the ranchers who caused the stampede, insisting it reflected badly on Colorado. The law banning Texas cattle didn't give them the right to shoot or stampede other people's property. The *Chieftain* even accused the Coloradans of using Texas Fever as an excuse for plunder. Disgusted with the editorials, a representative of the cattle organization wrote a letter to the paper, defending their actions for protecting their stock:

> *If the people of Colorado are in favor of encouraging the importation and growth of a wretched lot of scrub stock, that run all to head, horns, and legs, they can do so; but we don't believe they are. On the contrary, three-fourths of all the people of Colorado are directly opposed to the introduction of that character of cattle, and none are in favor of it but a few greedy speculators, whose interests are not in the least indentified with the growth and prosperity of our Territory.*[100]

The Curtis-Dawson crew moved on, but their trail boss was arrested. For his crime, he was fined fifty dollars and was allowed to continue with the herd.

THE LAST DOG SOLDIER

Still vowing never to submit to reservation life, Tall Bull led his warriors on successful raids through vulnerable settlements, railroad construction sites and stage lines. He was exacting revenge for a battle near present-day Wray, when three hundred warriors could not secure a victory against a mere fifty cavalrymen. The cavalry took cover in a sand bar in the middle of the Arikaree River, later called Beecher Island, somehow managing to fend off the charging warriors for nine long days. The Indians continued their daily barrage, but the determined soldiers prevailed. When Tall Bull and his warriors saw relief troops coming at them, the Indians scattered. It was a demoralizing defeat.

After the battle of Beecher Island, most of the warriors left for the north—but not Tall Bull. He continued raiding Kansas, this time taking two white female captives, Susanna Alderdice and Maria Weichel. The German-immigrant Weichel had settled on a farm when Dog Soldiers descended on her. They killed her husband and mutilated him while she watched. Alderdice's husband had not been home when they attacked her and the children. The Dog Soldiers shot her small sons with arrows (one

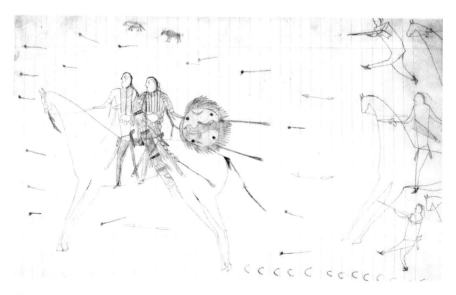

Cheyenne drawing depicting Wolf with Plenty of Hair carrying the dog rope and rescuing Tall Bull from a fight. *Courtesy History Colorado (Scan #10036173).*

survived), then grabbed her while she clutched her baby. The warriors carried them back to their camp, but the baby's constant crying angered them. Losing patience, they strangled her baby and left it in a tree before moving on to Colorado.

In July 1869, Tall Bull led his band across the central plains and then north to a favorite camping spot on White Butte Creek, later called Summit Springs, between present-day Atwood and Akron. The Sioux warriors with him argued that they should keep moving. They knew the bluecoats were on their trail and would catch up soon. Tall Bull wouldn't listen. Heavy rain of the past week had flooded the South Platte River just to the north of them, making it difficult to cross. Besides, his people and animals needed to recuperate. He ordered them to make camp, eighty-four lodges in all.

The next day, the Indians relaxed. The women gossiped as they finished their noon meals. The children jumped in and out of the water. The men lounged and smoked in the shade. In the early afternoon, Tall Bull sat with his three wives in his lodge. He played with his young daughter and kept an eye on the white women huddled nearby. Just after noon time, a strong and sudden storm blackened the sky. The winds picked up and whistled through the lodge skins, almost deafening. They never heard the sounds of horses and hoof beats in the hills above them.

To the north, William Cody and several Pawnee scouts peered over a rise in the hills. After weeks of pushing through dry terrain with little water and short supplies, they finally discovered Tall Bull's camp. When Cody reported back, General Carr prepared for battle. Mounting their gaunt mules and horses, the troops organized into three columns behind the hills. With the strong wind masking the sound of their movements, they flanked the village from the north, east and west, effectively cutting off an escape route to the river. With them were the North brothers, Frank and Luther, and their battalion of Pawnee scouts. The Pawnee were longtime enemies of the Cheyenne and anxious for a fight.

When all 250 men lined up behind the hills, the Pawnee and the North brothers led the charge into the village. The first to spot them was a teenage Cheyenne boy guarding the pony herd. Luther North remembered that boy:

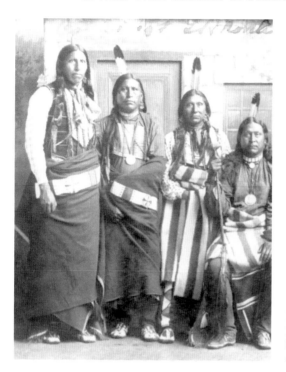

Pawnee scouts under Major Frank North's command at Summit Springs. *Courtesy Nebraska State Historical Society.*

He jumped on his horse, gathered up his herd and drove them into the village ahead of our men who were shooting at him. He was mounted on a very good horse and could easily have got away if he had left his herd, but he took them all in ahead of him. Then, at the edge of the village, he turned and joined a band of warriors that were trying to hold us back, while the women and children were getting away. There he died like a warrior. No braver man ever lived than that fifteen year old boy.[101]

The boy alerted the village only seconds before the bloody assault began. Scrambling pell mell, the Indians in camp had little time to grab weapons. The men put their women and children on whatever ponies they could catch, then urged them to the south. The Pawnee shot at their fleeing enemies, then doubled back to look for any fallen Cheyenne so they could smash the skulls of those left wounded on the ground. Following close behind were the cavalrymen and Cody. In his autobiography, Cody said they charged through the village, shooting right and left at everything they saw. Pawnees, officers and regular soldiers were all mixed together, while the Cheyenne and Sioux went flying in every direction.[102]

Tall Bull yelled for his warriors to take refuge in the nearby canyon, a sheltered crack in the hillside where natural springs had eroded the earth. He then darted back into the lodge for one final act of revenge against the whites. He wouldn't allow the soldiers the satisfaction of rescuing the captured white women. With the butt of a rifle, he cracked Alderdice's head open, splitting it like a ripe pumpkin.[103] Then Tall Bull jammed a pistol into Weichel's chest and shot her point-blank. One of his wives, Sun Woman, grabbed the pistol and shot Maria again to be sure she would die. As the white women lay bleeding in the lodge, Tall Bull jumped on his pony, pulled his wife and daughter behind him and rode to the canyon. At the entrance, Tall Bull dismounted and urged his wife and daughter behind the canyon walls. Then he turned to his favorite pony and plunged a knife into its heart. The whites wouldn't get his pony either.

The warrior who carried the dog rope, Wolf with Plenty of Hair, staked himself at the entrance of the canyon so his people could take defensive positions or flee to the south. In the canyon, Tall Bull and several warriors held off the relentless gunfire. A soldier spotted Tall Bull as he bobbed up to fire. He marked the position with his sights and waited. When he saw Tall Bull's head appear, he fired and blew him back with his bullet. A few minutes later, Tall Bull's wife and daughter emerged from the canyon and made motions of surrender. Tall Bull was gone. In less than twenty minutes, over fifty Cheyenne and Sioux lay dead in the canyon and along the creek. Not a single white soldier or Pawnee scout was killed.

After the battle, Frank North and another officer, Captain Cushing, dismounted at the edge of the village to take a drink from a keg sitting outside Tall Bull's lodge. At their feet, they were surprised by a white woman crawling out from the entrance. She cried out in German as she wrapped her arms around Cushing's legs. Although she had suffered two shots to the breast, Maria Weichel still clung to life. The men carried Weichel to the camp doctor, who removed the bullets and stitched her back up. But the doctor could do nothing for Susanna Alderdice. She had died instantly from her injuries.

In the morning, the soldiers wrapped Alderdice in blankets and buried her near the springs. Her husband would soon receive the sad report that she had not survived. As for Weichel, the men passed a hat and collected upward of $800 for her, not enough to compensate for the loss of her

Maria Weichel, captured by Dog Soldiers and rescued at the Summit Springs battle. *Courtesy Overland Trail Museum in Sterling.*

husband but enough to give her a new start. Weichel eventually remarried and moved to California.

After loading the stolen loot in wagons, the Fifth Cavalry filed out of the sand hills with seventeen Cheyenne women and children as prisoners. The soldiers set the lodges ablaze, leaving behind little fires that smoked up the hillsides. The bodies of Indian men, women and children still lay where they fell, left to rot on the open prairie. The last Dog Soldier, Wolf with Plenty of Hair, lay at the entrance of the canyon, his body still staked to the dog rope.

According to George Bent, Summit Springs was the last battle where a dog rope was used. And it was the final blow to the Plains Indians in Colorado. Never again would large villages of Cheyenne and Arapaho camp on the eastern prairie.

TRAIL'S END

As Cody rode down the Overland Trail toward Fort Sedgwick, a long line of soldiers and Pawnee scouts stretched a mile behind him. The Fifth Cavalry were a victorious but dejected-looking lot, with their played-out mules and broken-down wagons. After the battle, Cody searched for any more signs of Cheyenne Dog Soldiers: unshod hoof marks, lodge-pole tracks, moccasin prints. As he pressed on toward the fort, he found nothing but sagging telegraph lines and the caved-in remains of stage stations. By July 1869, the stations were disserted. The Indians had scattered. Wagon trains had disappeared. The transcontinental railroad had diverted all traffic to Wyoming, sucking the life from the old trail. Even the Godfrey family had left, leaving Fort Wicked abandoned. On the eastern plains, Colorado's Wild West days were drawing to a close. So too were Cody's days as a scout.

No longer would the trail hold the weight of the Colorado argonauts, those sturdy souls who shaped an unforgiving territory in perilous times. Whether longing to strike it rich or just craving adventure, each one embodied the stalwart and self-reliant character of the western frontier. Pioneers like D.C. Oakes blazed through angry go-backers, thousands of disappointed pilgrims who accused him of spreading gold rumors. Oakes saw possibilities in Colorado and decided to make the territory his home. As for his little guidebook, he wrote in his memoirs: "In spite of the large sale the guide-book had that year, I never personally received enough from it to pay the publisher. I don't know whether a copy of it is to be found today; but if there is, I would pay ten dollars to buy it."[104] Oakes worked as an agent for the Ute Indians in the latter half of the 1860s and then as a land surveyor until his death in 1887. His grave site—the real one—lies in Riverside Cemetery in Denver.

While men like Oakes helped settle the territory, others still sought the excitement of the untamed frontier. Ned Wynkoop returned to his family's iron business in Pennsylvania, but the former argonaut suffered from a bad case of itching feet—an insatiable desire to keep exploring. When rumors of Black Hills gold circulated in 1876, Wynkoop rode across the plains once again. Near Deadwood, he worked a claim for a time, then commanded a unit of Black Hills Rangers to protect miners from Sioux Indians. No longer a young man at age forty, he soon left South Dakota empty-handed.

Throughout his life, he hopped from job to job, eventually landing in New Mexico where his wandering ways crept up on his aging body. At fifty-five, Wynkoop died of kidney disease that stemmed from an old riding injury. After his death, his wife, Louise, returned to Denver where she became neighbors with John Chivington, the man her husband once called an inhuman monster. Although the Fighting Parson had softened in his old age, Wynkoop's sons still hated the old colonel for his vicious slander against their father. Yet Chivington was gracious to the family. When Louise had trouble wading through government paperwork to receive a much needed widow's pension, Chivington filed an affidavit on her behalf.

By the time of Wynkoop's death in 1891, the U.S. Census office had declared the western frontier officially closed. In fact, Colorado's eastern plains had closed long before that. The Homestead Act lured thousands of settlers to Colorado, giving each 160 acres of unclaimed land. Acre by acre, the small farmers consumed the open range, even the dry terrain where starving immigrants once died for lack of water. And when barbed wire was patented for mass production in 1874, settlers began permanently fencing off their property. Conflicts between farmers and cattle ranchers occasionally turned deadly in the territories west of the Mississippi, but the Colorado cattlemen quietly conceded that their range was no longer open or, at least, "less open" than it used to be. Changing with the times, Charles Goodnight moved his herd out of Colorado in 1876 and back to Texas, where he reportedly became the first rancher in the Panhandle to erect barbed-wire fences.

With all their adventures, the frontier trailblazers were ready-made characters for dime novels. Yet only a handful found fame in those blood-and-thunder tales. After the Summit Springs battle, William Cody crossed paths with a man who would launch the young scout into fame as Buffalo Bill; with that fame, Cody would forever preserve and mythologize the Wild West.

That summer of 1869, author Ned Buntline had read a newspaper article about Summit Springs. In particular, the achievements of the North brothers and their Pawnee scouts peaked his interest, so he boarded a train on a quest for a new hero. According to Luther North's account, the author disembarked at Julesburg and headed across the river to Fort Sedgwick where the Fifth Cavalry was in camp. When Buntline found Frank North, the publicity-shy major shook off the pesky scribbler. He told Buntline he

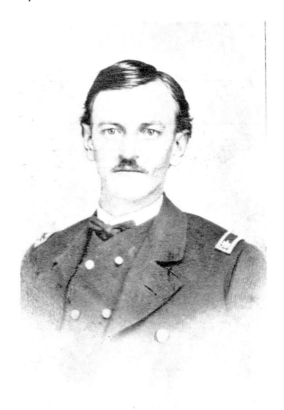

Portrait of Major Frank North.
*Courtesy Nebraska State Historical
Society.*

was no hero for his dime novels and that if he wanted "a man to fit that bill, he's over there sleeping under the wagon."[105] He was pointing to the gregarious young Cody.

During the cavalry's next expedition, Cody allowed Buntline to accompany him into the northern plains of Nebraska. The entire time, Buntline peppered Cody with questions until he had enough material for a series of stories. Buntline returned east, writing the first installment of *Buffalo Bill, the King of the Border Men* in the *New York Weekly*. It bore no relation to the Battle of Summit Springs and no relation to the truth whatsoever, but it helped launch Buffalo Bill into show business. In 1872, Buntline persuaded Cody to try stage acting. Although Cody's acting was abysmal and he suffered from stage fright, the eastern audience couldn't get enough of the handsome scout in buckskins.

After a decade on the stage and feeling limited by what he could do, Cody conceived a plan for a new form of entertainment. By combining his frontier

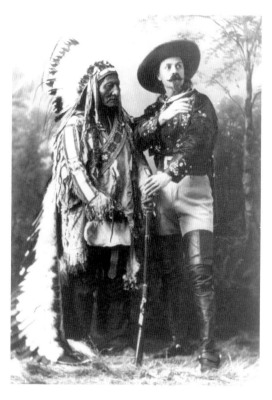

Portrait of Sitting Bull and Buffalo Bill to promote the Wild West show in 1885. *Courtesy Library of Congress, Prints & Photographs Division.*

knowledge with his talent for storytelling, he developed a show for an open arena, much like a circus attraction. From around the country, he recruited authentic western heroes—soldiers, scouts, Indians, cowboys and sharpshooters—all to capture the spirit of frontier life. Cody performed as the centerpiece for this highly dramatized Wild West extravaganza, a show that was a resounding success for many years throughout the United States and Europe. His Wild West played tribute to a remarkable history that lingers in our imaginations today, sparking the proliferation of the classic Western in books, television and movies, as well as the modern-day rodeo.

At the turn of the century, Cody was declared the greatest showman on earth. Yet for all his success in preserving the frontier he had lived and loved, he still felt a twinge of melancholy during performances. Reminiscing about his days in the ring, Cody wrote: "I am sure the people enjoyed this spectacle, for they flocked in crowds to see it. I know I enjoyed it. There was never a day when, looking back over the red and white men in my cavalcade, I did not know the thrill of the trail, and feel a little sorry that my Western adventures would thereafter have to be lived in spectacles."[106]

In 1917, an ailing and aging Cody died at his sister's home in Denver. His final wish was to be buried atop Lookout Mountain above Golden. There the old scout rests with a sweeping view of the plains—what was once the scene of Colorado's true Wild West.

Epilogue

In July 1876, several young men in Black Hawk decided to celebrate the nation's 100th birthday with a bang. Climbing a hillside above town, they searched behind the schoolhouse and found a tank lined with quicksilver—a perfect vessel for their explosives. Below them, the townsfolk observed the Fourth of July with picnics and speeches, entirely boring and predictable. The boys knew that this Fourth of July was especially worth commemorating: Colorado was about to become the 38th state.

Grabbing the quicksilver tank, they loaded it with powder, lit a match and ducked for cover. With an ear-splitting blast, the tank flew over the gulch like a missile, crashed through a hotel, plowed through three rooms and drove past the surprised faces of the boarders. Fortunately no one was hurt, but the boys laid low for a few hours while the smoke cleared and the rubble settled. Still, the citizens of Black Hawk weren't angry. Even with one of their finest hotels in dry dock for repairs, they could all agree their celebration far surpassed any of the orderly parades and baseball games down in Denver.

When Colorado achieved statehood, the tame little prairie towns may have matured into respectability, but the mining camps refused to relinquish their rollicking ways. In the late 1870s, a silver strike in Leadville sent a whole new wave of prospectors scurrying for Denver and the mountains above. Following close at their heels were swarms of thieves, scoundrels and pistol-packing prostitutes, all looking to fleece the honest citizens of the new centennial state. And despite all the citizens' best efforts to maintain law and order, the rowdy element infested their communities once again.

Official statehood or not, Colorado's Wild West lived on.

Notes

1. THE ARGONAUTS

1. Oakes, "The Man Who Wrote the Guide Book," 8.
2. Ibid., 10.
3. Gerboth, *The Tall Chief*, 46.
4. Ibid., 48.
5. Larimer, *Reminiscences of General William Larimer*, 48.
6. Ibid., 66.
7. Smiley, *History of Denver*, 214.
8. Larimer, *Reminiscences of General William Larimer*, 165.
9. *New York Times*, February 21, 1859.
10. *Rocky Mountain News*, April 22, 1934.
11. Perkin, *The First Hundred Years*, 92.
12. Ibid., 110.
13. Richardson, *Beyond the Mississippi*, 173.
14. Perkin, *The First Hundred Years*, 96.
15. Hyde, *Life of George Bent*, 106–7.
16. Hafen, *Overland Routes*, 271.
17. Blue, *Thrilling Narrative*, 13.
18. Hafen, *Overland Routes*, 271.
19. Oakes, "The Man Who Wrote the Guide Book," 9–10.
20. Ibid., 10–11.

21. Ibid., 13.

22. Perkins, *D.C. Oakes*, 73.

2. POLITICIANS AND OTHER SCOUNDRELS

23. Greeley, *An Overland Journey*, 159.

24. Richardson, *Beyond the Mississippi*, 186.

25. *Rocky Mountain News Weekly*, October 6, 1859.

26. *Rocky Mountain News Weekly*, October 27, 1859.

27. Gerboth, *The Tall Chief*, 68.

28. *Rocky Mountain News*, October 12, 1860.

29. Isern, "The Controversial Career," 5.

30. Gerboth, *The Tall Chief*, 70.

31. Monahan, *Julesburg and Fort Sedgwick*, 37.

32. Twain, *Roughing It*, 111.

33. Howbert, *Memories of a Lifetime*, 9.

34. Smiley, *History of Denver*, 349.

35. Edrington and Taylor, *The Battle of Glorieta Pass*, 38.

36. Easterbrook, *The Time Traveler*, 11.

37. Howbert, *Memories of a Lifetime*, 48.

38. *Rocky Mountain News Weekly*, September 10, 1859.

39. Guerin, *Mountain Charley*, 13.

40. Ibid., 64.

41. Ibid., 28.

42. Ibid., 57.

43. Zamonski and Keller, *The 59ers*, 15.

44. Perkin, *The First Hundred Years*, 178.

45. Gerboth, *The Tall Chief*, 56.

46. Dary, *Red Blood*, 126.

47. *Rocky Mountain News Weekly*, July 25, 1860.

48. Perkin, *The First Hundred Years*, 195.

49. Conard, *"Uncle Dick" Wootton*, 378.

50. Perkin, *The First Hundred Years*, 182.

51. Howbert, *Memories of a Lifetime*, 68.

52. Ibid., 72–73.

3. Rebels and Ruffians

53. Perkin, *The First Hundred Years*, 240–41.
54. Ibid., 248.
55. Ibid.
56. Isern, "The Controversial Career," 8.
57. Keeton, "The Story of Dead Man's Cañon," 36.
58. Tobin, "The Capture of the Espinosas," 64.
59. Conard, *"Uncle Dick" Wootton*, 406.
60. *Rocky Mountain News*, July 27, 1864.
61. *Daily Mining Journal*, July 27, 1864.
62. *Daily Mining Journal*, September 1, 1864.
63. Conard, *"Uncle Dick" Wootton*, 411–12.

4. The People of the Plains

64. Root, *The Overland Stage*, 331.
65. Hyde, *Life of George Bent*, 148–49.
66. Ibid., 339.
67. Gerboth, *The Tall Chief*, 88.
68. Lambert, "Plain Tales," 6.
69. Gerboth, *The Tall Chief*, 95.
70. Ibid., 146.
71. Howbert, *Memories of a Lifetime*, 120.
72. Prentice, "Captain Silas S. Soule," 227.
73. Hyde, *Life of George Bent*, 154.
74. Turner, *Forgotten Heroes*, 103.
75. Conard, *"Uncle Dick" Wootton*, 409.
76. Howbert, *Memories of a Lifetime*, 160.
77. Isern, "The Controversial Career," 11.
78. Gerboth, *The Tall Chief*, 102–3.
79. Ibid., 30.
80. Propst, *The South Platte Trail*, 39.
81. Hyde, *Life of George Bent*, 171.
82. Propst, *The South Platte Trail*, 88.

5. Vigilantes and Villains

83. *Rocky Mountain News*, November 23, 1868.
84. Cook, *Hands Up*, 29.
85. Ibid., 35.
86. Ibid., 41.
87. Stanley, *My Early Travels*, 166–67.
88. Cody, *An Autobiography*, 130.
89. Ibid., 131.
90. Ibid., 138.

6. Cowboys and Indians

91. Afton, Halaas and Masich, *Cheyenne Dog Soldiers*, 62.
92. Goff and McCaffree, *Century in the Saddle*, 18.
93. Moody, "Tales of the Cow Camp," no. 8, 14.
94. Ibid., no. 10, 18.
95. Ibid.
96. *Rocky Mountain News*, April 16, 1868.
97. Haley, *Charles Goodnight*, 262–63.
98. Ibid., 227.
99. Ibid.
100. *Colorado Chieftain*, April 29, 1869.
101. Grinnell, *Two Great Scouts*, 196.
102. Cody, *An Autobiography*, 148.
103. Cox, "Summit Springs," 302.
104. Oakes, "The Man Who Wrote the Guide Book," 14.
105. Warren, *Buffalo Bill's America*, 104.
106. Cody, *An Autobiography*, 239.

Bibliography

BOOKS

Abbott, Carl, Stephen J. Leonard and David McComb. *Colorado: A History of the Centennial State.* Boulder: Colorado Associated University Press, 1982.

Afton, Jean, David Fridtjof Halaas and Andrew E. Masich. *Cheyenne Dog Soldiers: A Ledgerbook History of Coups and Combat.* Boulder: University Press of Colorado and Colorado Historical Society, 1997.

Athearn, Robert G. *The Coloradans.* Albuquerque: University of New Mexico Press, 1976.

Atherton, Lewis. *The Cattle Kings.* Lincoln: University of Nebraska Press, 1961.

Barbaro, Barbara J. *Law and Disorder in Colorado City, 1859–1917.* Colorado Springs: Old Colorado City Historical Society, 2009.

Blue, Daniel. *Thrilling Narrative of the Adventures, Sufferings and Starvation of Pike's Peak Gold Seekers on the Plains of the West, in the Winter and Spring of 1859.* Chicago, IL: 1860.

Broome, Jeff. *Dog Soldier Justice: The Ordeal of Susanna Alderdice in the Kansas Indian War.* Lincoln: University of Nebraska Press, 2009.

Cody, William Frederick. *An Autobiography of Buffalo Bill.* Charleston, SC: BiblioBazaar, 2008.

Colton, Ray C. *The Civil War in the Western Territories, Arizona, Colorado, New Mexico, and Utah.* Norman: University of Oklahoma Press, 1959.

Conard, Howard Louis. *"Uncle Dick" Wootton: The Pioneer Frontiersman of the Rocky Mountain Region.* Columbus, OH: Long's College Book Co., 1950.

Cook, David J. *Hands Up; Or, Twenty Years Detective Life in the Mountains and on the Plains, Reminiscences by General D.J. Cook, Superintendent of the Rocky Mountain Detective Association.* Santa Barbara, CA: Narrative Press, 2001.

Dary, David. *Red Blood and Black Ink: Journalism in the Old West.* Lawrence: University of Kansas Press, 1998.

Easterbrook, Jim. *The Time Traveler in Old Colorado: Legends, Tales and Stories about Pikes Peak Country.* Colorado Springs, CO: Great Western Press, 1985.

Edrington, Thomas S., and John Taylor. *The Battle of Glorieta Pass: A Gettysburg in the West, March 26–28, 1862.* Albuquerque: University of New Mexico Press, 1998.

Friesen, Steve. *Buffalo Bill: Scout, Showman, Visionary.* Golden, CO: Fulcrum Publishing, Inc., 2010.

Gerboth, Christopher B. *The Tall Chief: The Unfinished Autobiography of Edward W. Wynkoop, 1856–1866.* Denver: Colorado Historical Society, 1994.

Goff, Richard, and, Robert H. McCaffree. *Century in the Saddle.* Boulder, CO: Johnson Publishing Company, 1967.

Greeley, Horace. *An Overland Journey from New York to San Francisco, in the Summer of 1859.* New York: C.M. Saxton, Barker & Co., 1860.

Grinnell, George Bird. *The Fighting Cheyennes.* Norman: University of Oklahoma Press, 1956.

———. *Two Great Scouts and Their Pawnee Battalion: The Experiences of Frank J. North and Luther H. North.* Lincoln: University of Nebraska Press, 1973.

Guerin, Elsa Jane. *Mountain Charley: Or, The Adventures of Mrs. E.J. Guerin, Who Was Thirteen Years in Male Attire.* Norman: University of Oklahoma Press, 1968.

Hafen, LeRoy R. *Overland Routes to the Gold Fields, 1859, from Contemporary Diaries.* Glendale, CA: Arthur H. Clark Company, 1942.

Haley, J. Evetts. *Charles Goodnight, Cowman and Plainsman.* Norman: University of Oklahoma Press, 1936.

Hoig, Stan. *The Sand Creek Massacre.* Norman: University of Oklahoma Press, 1982.

Hollister, Ovando J. *Colorado Volunteers in New Mexico 1862.* Chicago, IL: Lakeside Press, 1962.

Howbert, Irving. *Memories of a Lifetime in the Pike's Peak Region.* Glorieta, NM: Rio Grande Press, 1970.

Hughes, David R. *A Brief History of Reviving Old Colorado City.* Colorado Springs, CO; D.R. Hughes, 1978.

Hyde, George E. *Life of George Bent: Written from His Letters.* Norman: University of Oklahoma Press, 1968.

Jessen, Kenneth. *Colorado Gunsmoke.* Boulder, CO: Pruett Publishing Company, 1986.

Jones, William C., and Kenton Forrest. *Denver: A Pictorial History.* Boulder, CO: Pruett Publishing Company, 1985.

Larimer, William Henry Harrison. *Reminiscences of General William Larimer and of His Son William H.H. Larimer, Two of the Founders of Denver City.* Lancaster, PA: Press of the New Era Printing Company, 1918.

Lee, Wayne C., and Howard C. Raynesford. *Trails of the Smoky Hill, from Coronado to the Cow Towns.* Caldwell, ID: Caxton Printers, Ltd., 1980.

Michno, Gregory, and Susan Michno. *A Fate Worse than Death, Indian Captivities in the West, 1830–1885.* Caldwell, ID: Caxton Press, 200.

Monahan, Doris. *Destination: Denver City, the South Platte Trail.* Athens: Swallow Press/Ohio University Press, 1985.

———. *Julesburg and Fort Sedgwick, Wicked City: Scandalous Fort.* Sterling, CO: self-published, 2009.

Perkin, Robert L. *The First Hundred Years: An Informal History of Denver and the Rocky Mountain News.* Garden City, NY: Doubleday & Company Inc., 1959.

Perkins, James E. *Tom Tobin, Frontiersman.* Pueblo West, CO: Herodotus Press, 1999.

Perkins, LaVonne J. *D.C. Oakes: Family, Friends & Foe.* Denver, CO: Stony Ridge Press, 2009.

Propst, Nell Brown. *The South Platte Trail, Story of Colorado's Forgotten People.* Boulder, CO: Pruett Publishing Company, 1989.

Richardson, Albert D. *Beyond the Mississippi: From the Great River to the Great Ocean.* Hartford, CT: American Publishing Company, 1867.

Root, Frank A. *The Overland Stage to California: Personal Reminiscences and Authentic History of the Great Overland Stage Line and Pony Express from the Missouri River to the Pacific Ocean.* Topeka, KS: Crane & Co., 1901.

Russell, Don. *The Lives and Legends of Buffalo Bill.* Norman: University of Oklahoma Press, 1960.

Schoolland, J.B. *Boulder in Perspective: From Search for Gold to the Gold of Research.* Boulder, CO: Johnson Publishing Company, 1980.

Secrest, Clark. *Hell's Belles: Prostitution, Vice, and Crime in Early Denver.* Boulder: University Press of Colorado, 2002.

Smiley, Jerome C. *History of Denver: With Outlines of the Earlier History of the Rocky Mountain Country*. Denver, CO: Times-Sun Publishing Co., 1901.

———. *Semi-Centennial History of the State of Colorado*. Vol. 1. Chicago, IL, and New York: Lewis Publishing Company, 1913.

Stanley, Henry M. *My Early Travels and Adventures in America*. Lincoln: University of Nebraska Press, 1982.

Stone, Wilbur F. *History of Colorado*. Vols. 1–2. Chicago, IL: S.J. Clarke Publishing Company, 1918.

Tierney, Luke. *History of the Gold Discoveries on the South Platte River, by Luke Tierney, to Which Is Appended a Guide of the Route, by Smith & Oaks*. Pacific City, IA: Herald Office and A. Thomson, 1859.

Turner, Carol. *Forgotten Heroes & Villains of Sand Creek*. Charleston, SC: The History Press, 2010.

Twain, Mark. *Roughing It*. New York: Penguin Books, 1981.

Ubbelohde, Carl, Duane A. Smith and Maxine Benson. *A Colorado History*. Boulder, CO: Pruett Publishing Co., 2006.

Villard, Henry. *Memoirs of Henry Villard in Two Volumes*. Vol. 1. Westminster, UK: Archibald Constable & Co., 1904.

Warren, Louis S. *Buffalo Bill's America: William Cody and The Wild West Show*. New York: Vintage Books, 2005.

Werner, Fred H. *The Summit Springs Battle*. Greeley, CO: Werner Publications, 1991.

Whiteley, Lee. *The Cherokee Trail: Bent's Old Fort to Fort Bridger*. Boulder, CO: Johnson Printing, 1999.

Williams, Dallas. *Fort Sedgwick Colorado Territory: Hell Hole on the Platte*. Julesburg, CO: Fort Sedgwick Historical Society, 1993.

Wommack, Linda R. *Our Ladies of the Tenderloin: Colorado's Legends in Lace*. Caldwell, ID: Caxton Press, 2005.

Worman, Charles G. *Firearms in American History: A Guide for Writers, Curators, and General Readers*. Yardley, PA: Westholme Publishing, 2007.

Zamonski, Stanley W., and Teddy Keller. *The 59ers: Roaring Denver in the Gold Rush Days*. Denver, CO: Stanza-Harp Publisher, 1967.

ARTICLES

Block, Augusta Hauck. "Lower Boulder and St. Vrain Valley Home Guards and Fort Junction." *Colorado Magazine* 26, no. 5 (September 1930).

Bradbury, Patsy. "The John H. Gregory Legend." Roots Web at Ancestry.com, http://freepages.history.rootsweb.ancestry.com/~cescott/jhgregory.html (accessed on May 29, 2011).

Colorado Magazine. "The Statehood Celebration of 1876." 28, no. 3 (July 1951).

Cox, C. Jefferson. "Summit Springs." *Brand Book 1969 Silver Anniversary Edition* (1970).

De La Torre, Lillian. "The Haydee Star Company." *Colorado Magazine* 38, no. 3 (July 1961).

Englert, Kenneth E. "Raids by Reynolds." *1956 Brand Book of the Denver Westerners* (1957).

Gilmore, Zeralda Carter. "Pioneering On The St. Vrain." *Colorado Magazine* 38, no. 3 (July 1961).

Hafen, LeRoy R. "Elbridge Gerry, Colorado Pioneer." *Colorado Magazine* 24, no. 2 (April 1952).

Hayes, Marita. "D.C. Oakes, Early Colorado Booster." *Colorado Magazine* 31, no. 3 (July 1954).

Isern, Thomas D. "The Controversial Career of Edward W. Wynkoop." *Colorado Magazine* 56 (Winter-Spring 1979).

Jensen, Billie Barnes. "Confederate Sentiment in Colorado." *1957 Brand Book of the Denver Westerners* (1958).

Keeton, Elsie. "The Story of Dead Man's Cañon and of the Espinosas, As Told by Henry Priest to Elsie Keeton." *Colorado Magazine* 8, no. 1 (January 1931).

Kraft, Louis. "When Wynkoop was Sheriff." *Wild West* (April 2011).

Lambert, Julia S. "Plain Tales of the Plains," *Trail* 8, no. 12 (May 1916).

Moody, Dave. "Tales of the Cow Camp." *Trail* 2, no. 8 (January 1910)
———. "Tales of the Cow Camp." *Trail* 2, no. 9 (February 1910)
———. "Tales of the Cow Camp." *Trail* 2, no. 10 (March 1910).

Oakes, D.C. "The Man Who Wrote the Guide Book." *Trail* 2, no. 7 (December 1909).

Parker, C.F. "Old Julesburg and Fort Sedgwick." *Colorado Magazine* 7, no. 4 (July 1930).

Pennock, Ellen Coffin. "Incidents in My Life as a Pioneer." *Colorado Magazine* 30, no. 2 (April 1953).

Pitman, Kenneth, "The Battle of Glorieta Pass." *Denver Westerners Golden Anniversary Brand Book* 32 (1995).

Prentice, C.A. "Captain Silas S. Soule, a Pioneer Martyr." *Colorado Magazine* 12, no. 6 (November 1935).

Pyle, L. Robert. "Cheyenne Chief Tall Bull." *Wild West* (April 2002).

Stone, Wilbur F. "Early Pueblo and the Men Who Made It." *Colorado Magazine* 6, no. 6 (November 1929).

Sweet, Walden E. "Jury in Hell." *Rocky Mountain Life* (June 1948).

Thomas, Chauncey. "Frontier Firearms." *Colorado Magazine* 7, no. 3 (May 1930).

Tobin, Thomas T. "The Capture of the Espinosas." *Colorado Magazine* 9, no. 2 (March 1932).

Villard, Henry. "To the Pike's Peak Country in 1859 and Cannibalism on the Smoky Hill Route." *Colorado Magazine* 13, no. 6 (November 1931).

Winne, Peter. "Sketches of The Indian War of 1864." *Trail* 4, no. 11 (April 1912).

Witcomb, E.W. "Alfred Slade at Close Range." *Trail* 14, no. 6 (November 1921).

Zamonski, Stanley. "Colorado Gold and the Confederacy." *1956 Brand Book of the Denver Westerners* (1957).

NEWSPAPERS

Colorado Chieftain
Daily Colorado Republican
Daily Mining Journal
New York Times
Rocky Mountain Herald
Rocky Mountain News
Rocky Mountain News Weekly
Smoky Hill and Republican Union

Weekly Commonwealth
Western Mountaineer

Websites

civilwar.org
coloradoterritory.org
freepages.history.rootsweb.ancestry.com
historybuff.com
historycolorado.org (Colorado Historical Society)
kclonewolf.com
kshs.org (Kansas State Historical Society)
legendsofamerica.com
loc.gov (Library of Congress)
occhs.org (Old Colorado City Historical Society)

About the Author

Jolie Anderson Gallagher was raised on a farm in the Montezuma Hills of California. After earning an English/creative writing degree from the University of California at Davis, she has worked as a newspaper reporter and a technical writer. Gallagher has lived in Colorado for twenty-five years. She is a member of the Colorado Historical Society, the Wild West History Association and the True West Historical Society. This is her first book.

Visit us at
www.historypress.net

...

This title is also available as an e-book